Nakamura Keith Haring Collection: Approaching Primeval Energy

中村キース・ヘリング美術館
杜のなかの美術館

Chief Editor Kaoru Yanase
Translation Sawako Nakayasu, Gergana Ivanova, Dan Wever
Art Direction and Design Hinterland
Editing Yutaka Mikami, *Wako University*; Emiri Sakurabayashi, *Nakamura Keith Haring Collection*
Printing and Binding Cohber
Published by Kazuo Nakamura
Nakamura Keith Haring Collection
10249-7 Kobuchizawa-machi, Hokuto-shi, Yamanashi 408-0044
T 0551-36-8712
F 0551-36-8713
www.nakamura-haring.com
ISBN 978-4-9904168-2-9

Special thanks to the Keith Haring Foundation

Contents / 目次

People / 無題《人間(ピープル)》

The work entitled "People" is a large painting composed of numerous human figures intertwined together like patterns with no vertical-horizontal distinction. Mere black contours mark human bodies with no eyes or nose. In addition, colorful organic shapes in pink, orange, blue, and yellow-green spread throughout the panel. The human bodies overlay each other tightly, and look as if they are writhing, pushing and shoving, in attempt to move forward or at least feel slightly at ease.

However, the lack of expression in these people prevents us from determining whether or not this state is painful. In other words, viewed from a different angle, they all look as if they are dancing happily. Within this space, all the people, with no exception, mingle together. They unfailingly touch, help, love, and at times hurt each other, thus creating a bond. These are people

　無数の人間が、天も地もなくまるで紋様のようにからみ合い大きな画面を構成しているのが《ピープル》という作品だ。黒の線だけで、目も鼻もない、人間の輪郭が描かれている。そしてピンク、オレンジ、青、黄緑色といった色鮮やかな有機的なシェイプが全体を通して広がっている。人間は窮屈そうに重なり合い、押し合いへし合いしてもがき、何とかして前に、あるいはもう少し楽な方向に進もうとしているようでもある。

　しかし表情の描かれていない人間たちからは、この状況が果たして辛いのかどうかは特定できないのだ。つまり見方を変えればみんなで楽しく踊っているようでもある。空間内の人間は誰一人として交わっていないものはいない。必ずほかの誰かと触れあい、助け合い、愛し合い、ときに傷つき、そして絆が生まれているのだ。ここでは年齢も性別も学歴もない、パターン化された人間たち。しかし、言い換えれば、誰もが同等に扱われている。敗者も勝者もない。そして、背景にあるさまざまな色は、一人ひとりの個性の象徴でもある。この絵にヘリングは人が変貌する様を喩えたのか、生命の力を絆として表現したのか・・・。

made into a pattern regardless of age, sex, and education. Nonetheless, put in other words, they are all treated equally. There are no winners and losers. Moreover, the various colors in the background function as an expression of the individuality of each person. In this painting, did Haring attempt at a simile of a metamorphosis, or an expression of the power of life as a bond?

According to Darwin, it is not the clever or strong living creatures on the earth that have survived, but those who adapted to changes. This work of art made up exclusively of such extremely simple lines and flat colors, allows the imagination to stretch out endlessly, and just like a religious painting, connotes a wide range of meanings and raises profound questions about human life.

— Kazuo Nakamura

ダーウィンによれば、この世の地上の生物の中で生き残ってきた生物は、頭の良いものでも強いものでもなく、変化に対応した生物なのだという・・・。このきわめて単純な線と、平坦な色彩だけの作品から私の想像は無限に広がり、あたかも宗教画のように、私に多くの意味を伝え、人生への深い問いを投げかけるのだ。

— 中村和男

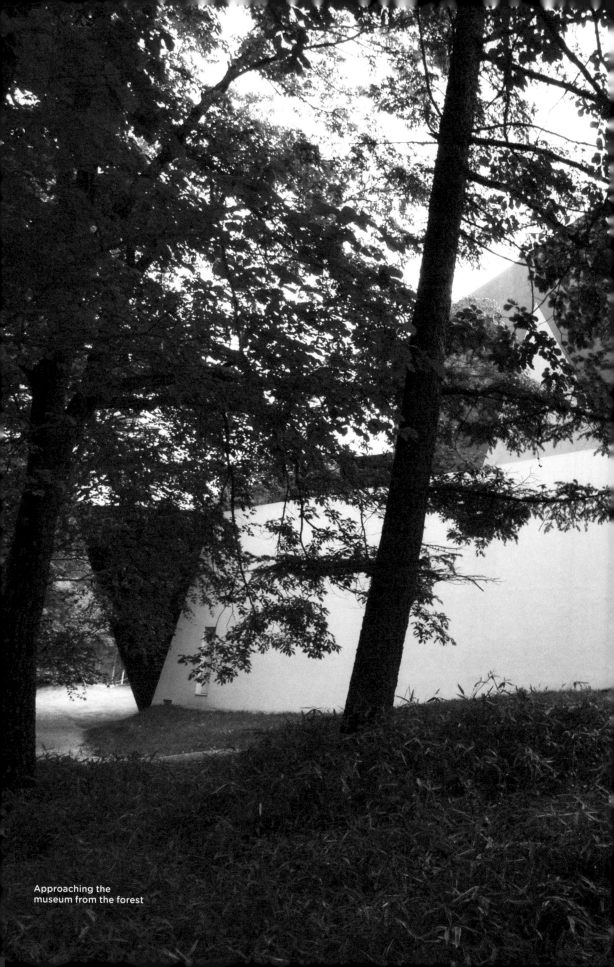

Approaching the
museum from the forest

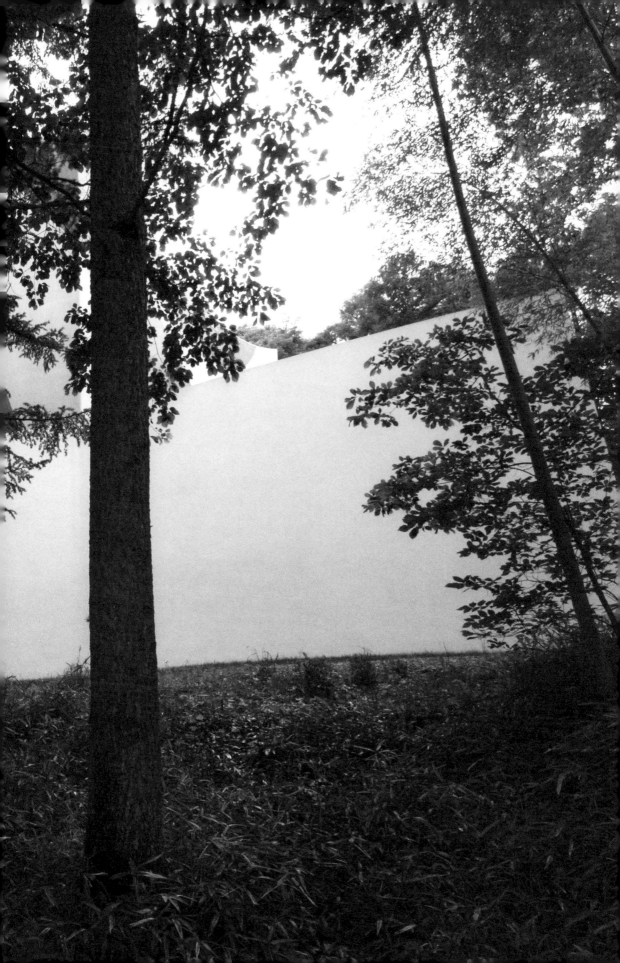

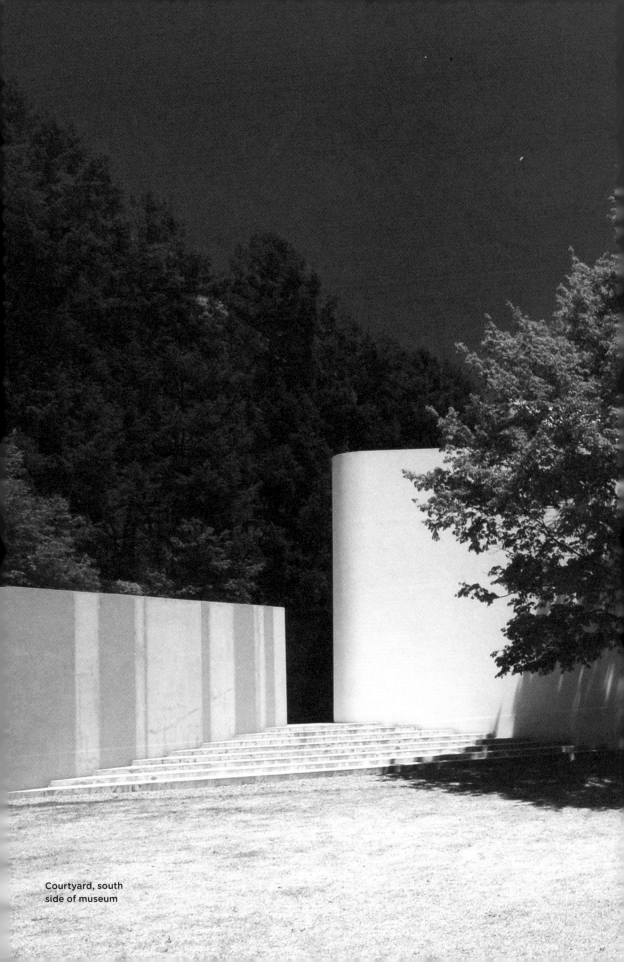

Courtyard, south
side of museum

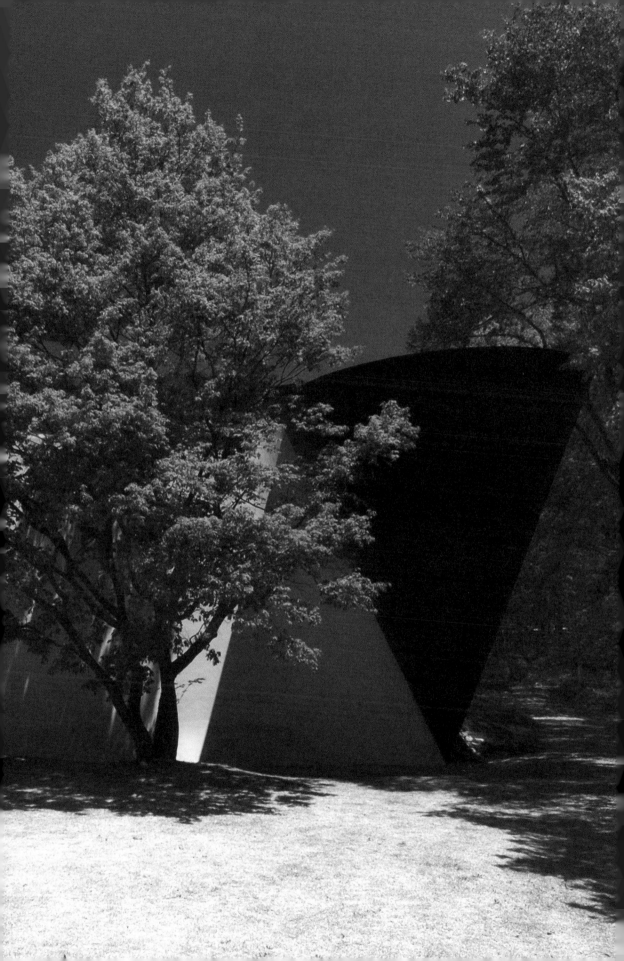

UNTITLED (#2 DUSSELDORF)
Sumi ink on paper
72x102cm, 1987

UNTITLED (PEOPLE)
Acrylic and oil paint on canvas
304.8x457.2cm, 1985

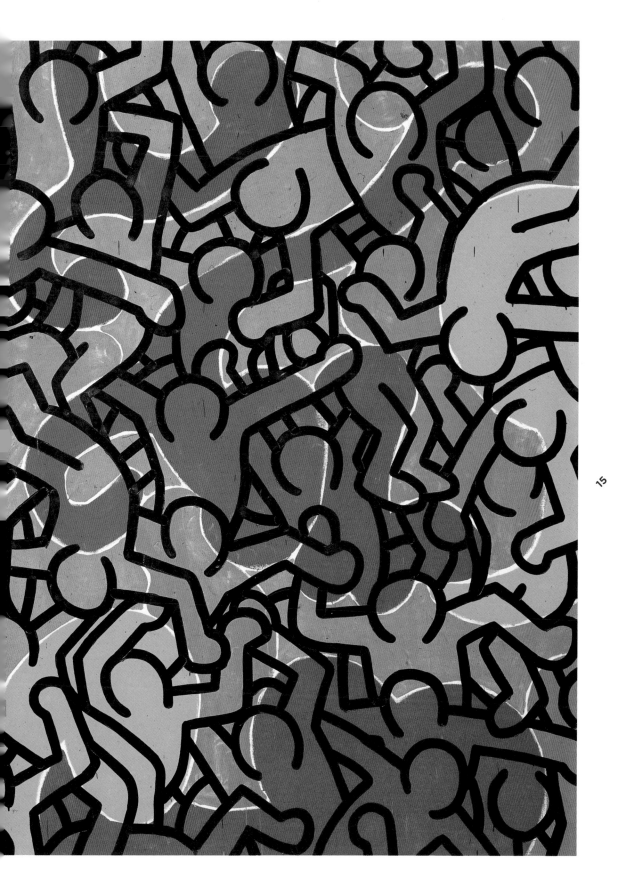

15

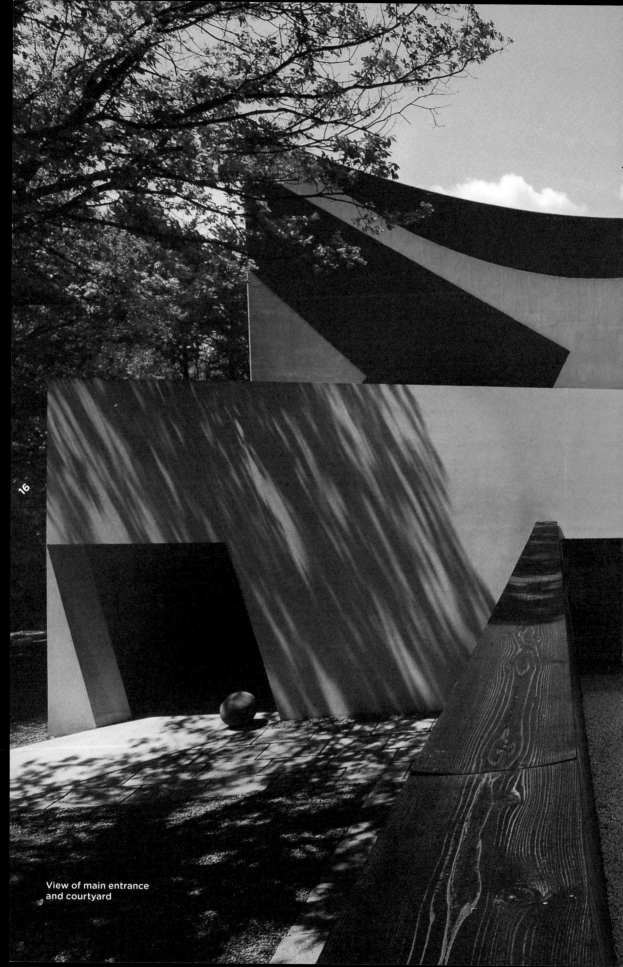

View of main entrance
and courtyard

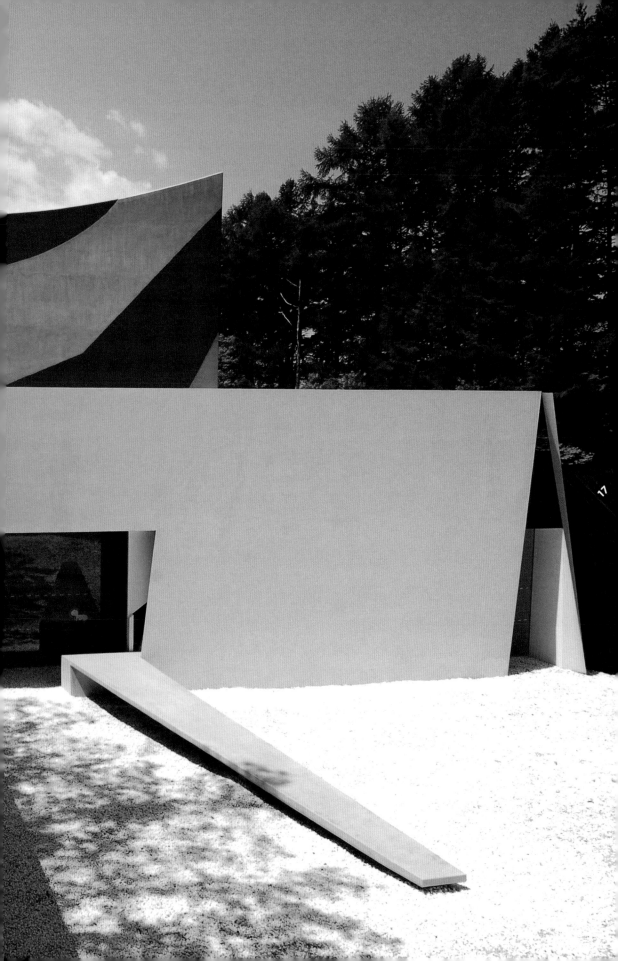

"Giant Frame" Gallery

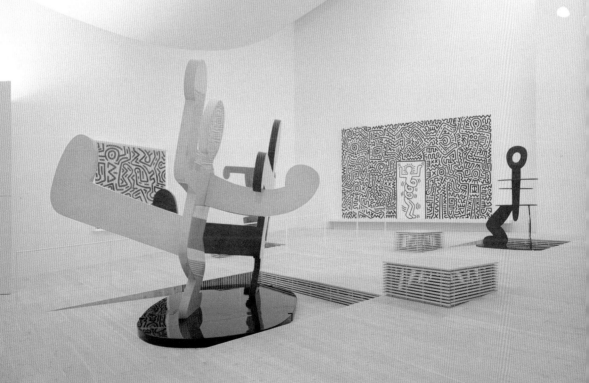

"Dream and Hope"
Gallery, a spacious room
with a reversed vault

Christina Laffin,
Kazuo Nakamura
and Kaoru Yanase
クリスティーナ・ラフィン、
中村和男、梁瀬薫

Keith Haring and Japanese Culture

キース・ヘリング
と日本文化

Kaoru Yanase / We're here to discuss Keith Haring and his connections to Japanese culture and Japanese people. Christina, you were born in Canada, traveled all over the world, and specialized in Japanese literature. Could you please start by telling us about your first stay in Kyoto? Mr. Nakamura has lived in Kyoto as well, so I would like to use this as our point of departure.

 Christina Laffin / I originally wanted to go to China, and had studied Chinese in high school. But when I received a scholarship from the Canadian government, they strongly encouraged me to go to Japan, and so I decided to go to Kyoto.
 I lived in Kyoto for a year. At first I had difficulty with certain aspects of communication. Whatever I asked of people, the response would always be, "yes, yes." In Kyoto, no one ever says "no." But the "no" exists beneath the surface of what they say, and it took me a long time to understand this. That was the most surprising thing.
 In high school I had read The Tale of Genji in English translation, and was very interested in it. When I was actually in Kyoto I felt like I could envision parts of the book there in that city, and felt that I wanted to keep studying it even after returning to Canada.

Kazuo Nakamura / I also lived in Kyoto from the ages of 18 to 22. Even as a Japanese person, I felt quite a bit of a shock. In a way, there are certain established formalities that are difficult

22

梁瀬 / キース・ヘリングと日本文化・日本人とのつながりというテーマでお話を進めていきたいと思います。
 まず、クリスティーナさん。クリスティーナさんはカナダのご出身で、今まで世界中を旅されたそうですね。ご専門は日本文学で、京都に滞在のご経験があられます。
 日本との関係...中村館長も京都にお住まいだったこともあり、まず最初に京都滞在のお話からお伺いできませんか?

 ラフィン / もともと中国に行きたくて、高校時代は中国語を学びました。でも、カナダ政府の奨学金を受給できることになったときに、当局から日本行きを強く勧められたのです。そういう背景があって、京都行きを決心しました。
 京都には1年間滞在しました。最初はコミュニケーションに戸惑いました。何を聞いても「うん、うん」と応えてくれるのです。「ノー」を聞いたことがありません。でも、注意しなければならないのは「うん」の本意が「ノー」の場合があることです。それを理解するのにずいぶんと時間がかかりました。これが一番驚いたところです。
 私は高校時代に興味があって英訳された「源氏物語」を読んでいたのですが、実際に京都にいると、街の中でも源氏を感じる部分があり、カナダに帰国後も「源氏物語」の勉強を続けようと考えていました。

中村 / 私も18歳から22歳までの学生時代、京都に暮らしていました。日本人でも京都の文化には結構なショックを受けます。形式美が出来上がっていて、慣れるまではなかなか理解できない。例えば、京都の家を訪問し「ぶぶ漬け (お茶漬け) でもいかがどす?」と聞かれたら、「そろそろ帰ってください」という意味が含まれているのです。最近はそのような事も少なくなったと思いますが、私が京都にいたときには伝統的な風土が残っていたので初めは戸惑いました。

to understand even upon contemplation. For example, the woman running the boarding house where I lived would tell me that I should go ahead and take a bath, but when I actually went, there would be no water in it.

When Keith came to Japan in 1982, I imagine he also must have undergone quite a shock. So to begin, I'd like to ask Christina in what sorts of instances did you encounter Japanese-ness?

L / When I first arrived, I had the strong sense of needing to follow a lot of rules. There were rules regarding everything, and I thought I would embarrass myself if I didn't learn them all quickly. But it turns out that there are many people who break the rules, and it became apparent that rules are made to be broken.

N / This is kind of a leap, but do you know about yobai (night crawling)? They say that yobai took place in Uji, where you were living. They'd welcome anyone, basically, to yobai, and then people would go and spend the night. From a legal perspective it's kind of sketchy, right? But there are even rules regarding the children who are born as a result of yobai.

L / Yes, when I was first taken to a festival in Uji, I was surprised. They made [statues of] male and female genitalia as if for some kind of performance, and carried [them] to the shrine while dancing. Everyone was waiting there in the dark, like it was a place

　　キースは1983年に初来日しているのですが、彼もかなりショックを受けたのではないでしょうか。クリスティーナさん、あなたが遭遇した日本人らしさを感じた出来事をお聞かせいただけませんか？

　　ラフィン / 最初の来日では、たくさんの生活上のルールを守らなければならない、というところが印象的でした。何にしても色々なルールがあって、それを早く学ばなければ恥ずかしい思いをするのではないかと思っていました。でも、実はルールを破っている人ってたくさんいるのですね。ルールは破るためにある、というのがだんだん分かってきました。

　　中村 / 破ってもよいルールとそうではないものとがあります。たとえば、突然ですが「夜這い」ってご存知ですか？クリスティーナさんが住んでいた宇治で「夜這い」が行なわれていたと言われています。「夜這い」は、昔の日本において生活共同体としての村の中で組織的に行われていた慣行で、結婚相手を探したり、人口を調整する機能を果たしていたと考えられています。原則として男性なら誰でも、夜、女性宅を訪ねて行って一夜を過ごすことができるのですが、法的観点からは、ちょっと問題ありますね。しかし、その中にもきちんとルールがあり、当事者同士の合意はもちろんのこと、「夜這い」でできた子であってもちゃんと地区全体で育てるルールがあるのです。これはずっと守られてきたルールです。「道徳」と言っても良いかもしれませんが、日本人は古来より道徳観に基づいて行動することに長けているのだと思います。

　　ラフィン / そうですね。宇治のお祭りに初めて連れて行ってもらって、驚いたことがあります。どう見ても男女の性器が出し物として出ていて、みんなが踊りながら神社まで運んでいくのです。暗闇の中、みんなそれを待っているのです。まるでそこが夜這いの場を模しているかのように、絶対火を炊いてはいけません。

for sexual relations. You absolutely couldn't light any kind of fire, and the people in all the neighboring houses were also waiting in the dark. When I first saw this I thought it was the strangest thing. But actually this yobai culture has existed since the Manyo era, and these ancient roots reveal themselves in the festival.

N / At present, people who were born of the yobai tradition are probably in their 40s and 50s. There are few of these regions remaining, so they know who was born to whom.

The rules that you were just referring to even though Japan can bind you hand and foot with rules, behind all that, actually, there are many things happening that can't be understood in terms of these rules. Yobai is one of these things. If you take it a step further, you have gay culture. As you know, homosexuality has long existed in Japanese culture. You know, like the monks, the daimyo (feudal lords) and the kabuki actors. They were routinely accepted, but then there was a certain kind of thinking there. It was systemized, the rules of this world, and they were living within them.

L / Even while breaking the rules, they are institutionalized to a certain extent. If you take the chigo system (pederasty), for example, it gave birth to much of Japanese traditional performing arts. Without the chigo system, we wouldn't have had artists like Zeami, and we probably wouldn't even have Noh theater today.

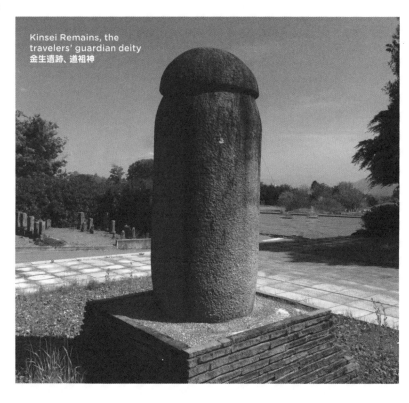

Kinsei Remains, the travelers' guardian deity
金生遺跡、道祖神

It's all mapped out well, so it's not about breaking or not breaking the rules it's established as a single system.

N / Surprisingly, many Japanese people today don't know about these things. But it all continues endlessly in a way. And perhaps this has at its roots the sensitivity and complexity of Japanese people. When I first thought about what it meant to be Japanese, in terms of the theme for today's talk, I thought about how although it seems that there are many rules, Japanese people are actually quite tolerant. But then when you turn to look at The Tale of Genji, you have to wonder if it's a great romance novel, or if it's a pornographic novel. Christina, you taught The Tale of Genji abroad, what was your experience of that?

L / They always hate Genji. I give them the historical context and a range of background information, but their first reaction is always that they dislike Genji.

N / Why do they hate him?

L / Most students, men and women both, say it's because he rapes women. So then we discuss the marriage practices of the time, or the social standings of Genji and each of the women, the political climate, the historical background and then they gradually begin to shift their perspective.
Genji may have been a player, but when you read the scholarship on it you start seeing how each of his relationships

周りの家もみんな明かりを消して待っている。その光景を最初に見たときには不思議でしかたがありませんでした。きっと万葉の時代からその「夜這い」の文化があって、ルーツがそういう祭りを通して見えてくるのです。それは、道徳を重視しているからこそ、ルールにはあまり束縛されることなく行動する日本だからこそ、受け入れられてきた文化かもしれません。

中村 / 明治時代になって急速に少なくなったのですが、「夜這い」でできた子どもたちは今でも生存しています。その地区の人たちは知っているのですね、どこの誰の子どもかということを。
　先ほどクリスティーナさんがおっしゃったとおり、日本はがんじがらめのルールがあるにも拘らず、実際にはルールという枠では説明のつかないことがたくさん行われて、許容されているのです。「夜這い」もその内の一つです。また、「ゲイ」もそうでしょう。ご承知のとおり「ゲイ」は日本には古くからあります。武将や大名と小姓などにもそういう関係があったと言われています。「ゲイ」が文化として当たり前のように許容されていた日本は、多くのことを許容する多様性と柔軟性を兼ね備えた社会だったのです。それぞれの世界に、道徳的価値観の上に形成されている制度的な仕組みがあって、その中で生かされているようなところがあります。

ラフィン / ルールを破っても、制度として成り立っているのですね。
　例えば、昔の稚児の風習にしても日本の多くの伝統芸能を生む下地になっていたと思います。稚児の風習がなければ世阿弥の登場はなく、能は多分存在しなかったのではないでしょうか。ルールを破る、破らないではなく、一つの仕組みとして成り立っているのです。

with the women took place within a certain set of rules,
and it gets pretty interesting when you look at it that way.

N / It was around 1987 when I was on a business trip abroad that
I first encountered Keith's work. It was a painting called "People's
Ladder," depicting people sitting atop one another's shoulders.
For some reason I was very drawn to it. But I was shocked when
I learned how much it cost. I wondered if it was right that it cost
so much, but the gallery owner said I could pay in installments, so
I ended up purchasing the painting. In my own way, I saw something
really pleasant in it. It's easy to understand. The most important
thing is that in many of his paintings, people are in relation to each
other. People cannot live alone, they have relationships with others.
They involve others, and there's a sort of movement in that. I must
have been very interested in that kind of depiction.

And then from there, I was hooked. I kept collecting his works,
struggling with the thought that I would go to ruins if I kept
spending my money on Keith. At some point I decided that this
shouldn't just be for myself, and that I wanted to share it with
others. But I think that I felt something in his paintings that others
do not feel. That there was something behind them. That they
weren't simply cheerful images, but that he painted with such
sensitivity, such psychology. Perhaps this is a characteristic of
Japanese people to look deeper into things.

中村 / 今の日本人は、案外そういうことを知らない。だけど、脈々と引き継がれてい
るところがある。もしかしたら、日本人の繊細、かつ複雑性がその根本にあるのか
もしれません。
　改めて、日本人とは何かと考えますと、たくさんのルールを作るくせに、そのルー
ルをとてもおおらかに運用しているのですね。日本人特有の繊細性があるからこ
そ、おおらかな運用でも社会として成り立つのではないかとも考えます。
　例えば、「源氏物語」について、これは壮大な恋愛小説と受け止めますか?それ
ともポルノチックな小説だと受け止めますか?クリスティーナさんは「源氏物語」を
海外で教えておられて、どういう印象をお持ちでしょうか?

　　　　　ラフィン / 　学生はまず、源氏を嫌います。歴史的なコンテクストとか背景を教える
　　　　　のですが、それでも源氏が嫌いだというのが最初の反応です。

中村 / なぜ嫌うのですか?

　　　　　ラフィン / 男子学生も女子学生もほとんどの学生が、女性をレイプするから嫌いだ
　　　　　と言います。
　　　　　　そこから当時の結婚制度や源氏の立場やそれぞれの女性の立場、政治的状況、
　　　　　時代背景を説明していきますと、徐々に視点が変わってきます。
　　　　　　源氏はプレイボーイだったのでしょうけれども、文献をあたりますと各女性との
　　　　　掛け合いはルールに従っているのであって、そこに注目するとなかなか面白いなと
　　　　　思います。まさに、日本人の繊細さとおおらかさを読み取ることができます。

中村 / 87年頃、海外出張をしているときに初めてキースの絵に出会いました。
「ピープルズラダー」という肩車の絵なのですけれども、なぜかすごく惹かれました。

L / When you first see Keith's paintings, the simplicity is very attractive. And then the deeper messages behind the work come out gradually.

When I spoke about Keith to my mother back in Canada, it made her very happy. She's a woman of the 60s. She knew that Keith Haring was a very influential artist, but my brother, who is ten years younger than me, had never even heard of him. He said he wasn't interested, saying it was the kind of art a three-year-old could make. But as he looked at the pictures my mother showed him, he seems to have gradually come to see that it wasn't so superficial.

N / Many people kept asking, why Kobuchizawa? We've never heard of Kobuchizawa; isn't it out in the middle of nowhere, they said, claiming that it was impossible to understand [his work] outside of the urban environment. They said it would make more sense if it was in Tokyo, but they were very reluctant about building it here.

Y / Yes, because Keith was someone who stormed his way through New York in the 80s when it was a chaotic place, and sex and drugs and violence were widespread. Of course AIDS was part of that too. It was a time when pleasure and death were two sides of the same coin. You could say that those works of his came to be only because it was that kind of time and place.

But why should we be limited to perpetuating this legend

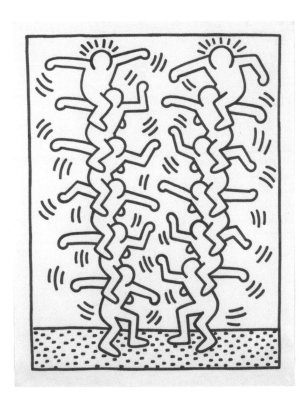

UNTITLED (PEOPLE'S LADDER)
Marker on paper
73x58.5cm, 1985

from the 80s? Mr. Nakamura is very interested in exploring what happens when you use Keith's paintings as a medium, thinking about how we interpret the messages that we draw from them, and how we transmit these messages to future generations.

It means that he chose to build here so that it wouldn't just be confined to its historical place in the 80s, or for the purposes of art criticism.

Japan has always had a kind of two-dimensional aspect, in the work of Hokusai, for example. I'd like to ask Christina to talk about literature, as well as the fact that Keith had long been interested in manga culture. But what's at work here is that even if you're looking at these two-dimensional works of his, you seek out the elements that lie deeper within. What do you think?

L / When I first heard about the museum, I also thought that there was something suspect about his connection to Japan. I wondered why this was being built here.

There is a lot of evidence regarding how Japanese culture and literature had influenced Keith. When you read his diary you see that he was attracted to Japanese calligraphy. He also made his Tokyo Pop Shop in Japan, and it's apparent that he had had quite a lot of interactions with Japan.

But what's more important is the question of why there is a Keith Haring museum here, and whether it has meaning. That is to say, how will his message get transmitted. If you look back towards

一見では単純な絵に見えて微笑ましいのですが、その奥には社会に対する問題提起や皮肉などが込められていて、強い印象を受けました。彼の作品は人をテーマにしたものが多いのですが、人間の躍動を感じます。人は一人では生きていけない、誰でも人と絡んでいく、そんな当たり前のことを強く意識させるような、そういう描写に大変興味を抱いたのです。

それから、はまり込むわけですが、これはもう私だけでなく、みなさんにもお見せしたいという思いがだんだんとこみ上げてきたのです。私はキースのあの絵に他の人が感じないものを感じていたのだと思います。あの絵の裏にある何かを。ただ単に明るいだけでなく、繊細で、心理学的な描写に何かを感じた。これは物事を深く見つめることができ、古来より異文化を取り込むことのできる多様性や柔軟性をもつ日本人の特性なのかもしれません。

けれど、最初一枚を購入する際に値段を聞いて驚きました。こんな漫画みたいな絵にこんな値段がついていいのかと思いましたが、その画廊主からローンでもいいからと言われて、1枚購入したのです。それから、このまま買い続けていったら破産するぞ、と葛藤しつつも、キースの絵に魅了されている私は収集し続けてしまったわけです。

ラフィン / キースの絵を見ると、まず、その単純さにすごく惹かれますね。その後にもっと大事なメッセージが裏にあるのだなということが段々分かってくる。

カナダの母とキースについて話をしていたら、彼女はものすごく喜んでいるのです。母は60代なのですが、キース・ヘリングが大きな影響を及ぼした芸術家であることをよく知っていました。一方で、私の10歳年下の弟は全然知らなかった。初めてキースの絵を見たとき、その弟は3歳の子供でも描けるような絵だから興味はない、と言っていましたが、母にキース・ヘリングの絵を見せられているうちに、表面的ではないメッセージがあることに気がついたようです。

traditional Japanese culture and literature, first you might study waka but if you read waka as a foreigner there's something very unnatural about it. With haiku, too, what you evoke is very different from what Japanese people of the time were seeing. If you were an intellectual to some degree, you would know that waka is a medium for love, as it's also a means of simply sending a message, as with a letter. It was also used to simply express feelings of sadness or regret, like you can see in the Izayo nikki. Waka was used as material for a variety of things. I think that this is the manner in which I would like to continue to study Keith's works.

N / What I'm always thinking is that elements like the title of a work can be rather secondary. What's important is to simply look, and feel something.

Also, perhaps even more than the work itself, I want to understand the times that he lived in and stormed his way through in his youth. Those times were filled with so much energy. I want to understand his worries and anxieties.

Right now, I think we feel a kind of listlessness. There's no one around who's fiery, no one who's really kind of out there, madly futuristic. I want to be able to share the energy that I myself received from Keith Haring, the things he was trying to tell me, and connect it all with our hopes and dreams.

As we were talking about just before, why Kobuchizawa? There is a place here called Yatsugatake, where the Jōmon culture once

Misogi Shrine, the written fortune
身曾岐神社、おみくじ

flourished. It's a site of tremendous life force. If you go backwards in time, you could say that it's reminiscent of the energy of the city where Keith once lived. You find here something fundamental of nature, or even of the universe. So it's not about Keith's individual pieces, and about transmitting them from a city like Tokyo or New York. My hope is to transmit from this land something simpler, like our hopes and dreams.

L / Keith wrote in his diary that in his current life he can be interpreted as a New Yorker, but in his past life he was a Japanese painter. He was quite aware of these things that's to say, if he was a Japanese painter in a past life, perhaps we can even place him in Kobuchizawa in his next life.

Y / Keith Haring passed away when he was 31, but for the last five years or so of his life he was in direct confrontation with death. He was living with the awareness that he was going to die.
　He was smart, and accepted things honestly, and did everything he could, but I think there was at least one thing that he couldn't be a part of. At the time nobody really noticed, but now ecology has become a prominent topic. Since there weren't computers then, he died without really knowing about PCs, ecology, and environmental issues. Of course, before he died he was very interested in IT, and he also wanted to do anime. He wanted to collaborate with Disney, so if he had been alive it's

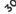

30

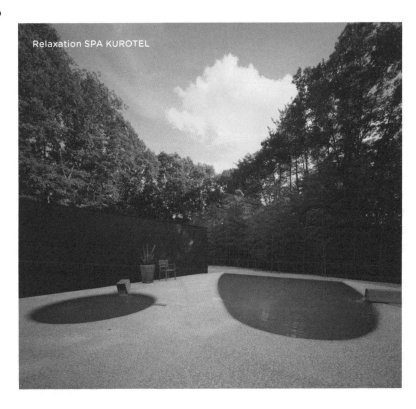

Relaxation SPA KUROTEL

likely that he would have been very good with computers. As he was a person who was quite in tune with the times, if he was alive today undoubtedly he would be interested in ecology and such. Although of course these are just my personal imaginings. Christina, you said you were quite moved when you visited the Idojiri ruins nearby.

L / In Vancouver there is a famous anthropology museum, and the Haida tribe aboriginal crafts there were quite similar to the Jomon period frogs and aboriginal totem poles that I saw at the ruins here. It made quite an impression on me. What surprised me even more is that when you enter this museum the first thing that you see is the totem pole that was very surprising.
 The other thing that surprised me is the hot spring spa that is connected to the garden of the museum.

N / To me the hot spring is the energy of the magma itself, and is also a symbol of life.

Y / The spa was designed by Atsushi Kitagawara, as was the museum.
 The totem pole that Keith made is similar to the objects that aboriginal people use in their ceremonies. How do you feel that it relates to the Jōmon period, Mr. Nakamura?

中村 / ここにキースの美術館を作るときに、多くの方から小淵沢なんて知らない。田舎ではないか、キースは都会でしかわからない、わかるはずがない。東京ならわかるけど小淵沢に作るのがわからない、と抵抗がありました。

梁瀬 / そうですね。キースは80年代ニューヨークを駆け抜けていった人なのですけれども、混沌としたところで、暴力とかセックスとかドラッグとかが蔓延していた、もちろんエイズもそうなのですけれども、快楽と死が背中合わせにあった時代の、そしてそういう都会だったからこそあの作品はできたということもあるかもしれません。
 しかしなぜ、いつまでも80年代のレジェンドだけを引き継いでいかなければいけないのか。たとえばキースの絵を媒体の一つと捉えて、そこから出てくるメッセージを、どういう風に私達は解釈し、解釈したメッセージをどのように未来へ伝えていかなければならないのかというところに、中村館長はすごく興味がある。その結果が80年代の歴史性、美術評論性とそういうことではなく、多分、ここに建てたという意味ですよね。
 文学のことはこれからクリスティーナさんに説明していただこうと思いますが、日本には葛飾北斎に代表される浮世絵という平坦な文化があったのですね。漫画文化にも昔から慣れていたということもあって、キースのような平坦な絵を見てもその奥にある要素を探ろうとすることが働いたかと思うのですが、どうでしょうか？

ラフィン / 私も初めて美術館のことを聞きましたときにキースと日本の接点に疑わしいところがあって、なぜここに美術館ができるのだろうと思いました。キースがどのように日本文化や文学に影響を受けたのか、それはいろいろと証明されていて、日記をみると、日本のカリグラフィー、つまり書道などに惹かれています。

N / Yes, from a scientific and genetic viewpoint, it is thought that the first persons to set foot in Japan as man dispersed from Africa about 10,000 years before what we now call the Jōmon period were in fact the Jōmon people, and again this is from a genetic standpoint. As is well-established now, the next to arrive came from the Asian continent. More specifically they came from Korea, and to put it extremely, genetically the Jōmon people parted ways towards Hokkaido in the north and Kyushu in the south, and that is in the roots of Japanese people today. The Jōmon people had thick eyebrows and hair and bushy beards. After that, the people who came into Japan had thin and flat eyebrows, and that is where our roots are.

Most likely because of those shared origins, the culture of the Jōmon period greatly resembles African art. There are very unexpected artifacts that come out of the Jōmon ruins, that resemble African art. Isn't this African art? How do these things that are so different from my sensibilities come from here?

Also, they find things that show how the people of the Jōmon period were very aware of the universe and the four seasons and such. Keith also seems to have been influenced by African art and was quite aware of the pyramids and spaceships and such. Here you can feel a similar kind of power, and vitality.

As a result, although the question of where Japanese people came from is an archeological question and a difficult one, if you only look at it scientifically there is no doubt that the Jōmon

また、東京ポップショップを開いたり、実際に日本との交流が明らかにあったのです。ただ、もっと大事なのは、なぜここにキース・ヘリングの美術館があって、どういう意味があるのかというところ。つまり、彼のメッセージをどう伝えていくのかというところです。

日本の伝統文化や文学のほうから振り返ってみると、最初に和歌から研究していくのですが、外国人として和歌を読むととても不自然な部分があり、当時の日本人とは連想していくものが全然違います。俳句にしても同じです。ある程度の知識人であれば、和歌を恋愛の媒介として、手紙のように簡単にメッセージを伝えるものとして、あと悲しい時とか悔しい時にも使っていました。「十六夜日記」にも残っているように何か単純に感情を訴えたいときにも使われました。和歌はそういう色々な素材に使われています。

キースの絵も、表面的なものから深層的なものまで、色々な側面からメッセージを読み取ることができることから、ある意味では和歌に通ずる部分がある。そんな風に、私は今後キースの作品を見ていきたいなと思います。

中村 / キースの作品を鑑賞するにあたっては、作品名などは二の次で良いと思っています。とにかく、見て感じて下さい。80年代という時代を駆け抜けるように生きたキース・ヘリングというアーティストが放つエネルギーを、まずは体感してほしい。それから、若いアーティストが何に悩み、苦しんだのか、そこを理解しながら見るとまた違う印象で感じることもあると思います。とにかく、キースの作品は私たちの動物的な感性に訴えてくるものであり、エネルギーやパワーを与えてくれます。

「なぜ、小淵沢なのか」という質問の答えもそこにあります。小淵沢がある八ヶ岳は昔、縄文文化が栄えた場所で、古来より文化が生まれる素養があった。つまり、文化を生み出すほどのエネルギーあふれる土地だと言えます。

people are descended from Africa and brought that culture with them. As you keep going back in history, there are definitely things that resemble African art, and there is also a similarity to Keith's works. And it's a fact that the Jōmon people were in Kobuchizawa. But the work of scientifically tracing our roots one step further has yet to be done.

L / Yes, aboriginal art as icon is, very simply, incorporated into many things.

N / Speaking of icons, the Japanese novel The Tale of Genji comes out of the salon culture of the Heian period, but on the other hand you have the life of commoners. There you have something called dōsojin, a traveler's guardian deity. This is something really amazing, and very benevolent. What the dōsojin, with his enormous penis, and Keith's portrayal of sex have in common is quite interesting, isn't it? They're portrayed so cheerfully.

L / This morning, I saw a number of Keith's works in the museum, where there were many joyful depictions of the penis. Seeing the actual work here, they seem even more joyful. I find myself laughing as well. There's nothing frightening about it.

N / In other words, it touches something fundamental in humans. Something that I've discovered since establishing this museum is

Misogi Shrine
身曾岐神社

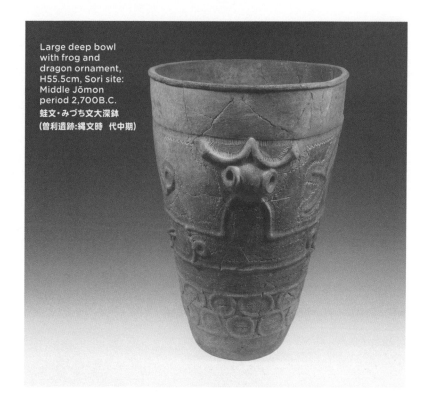

Large deep bowl
with frog and
dragon ornament,
H55.5cm, Sori site:
Middle Jōmon
period 2,700B.C.
蛙文・みづち文大深鉢
（曽利遺跡:縄文時　代中期）

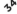

そこに、他民族が集まる大都市ニューヨークで生み出されたキースの作品が安住
している、すごく面白い構図だと思います。また、当時の縄文土器にある図柄と
キースの平坦なイラストには共通したダイナミズムや躍動感を感じます。この閉塞
的な現代社会にこそ、そういうものの重要性が増していると思います。
　　若いうちは、型にはまっていてはいけないのです。もっとギラギラと精力的に生き
ている若者が増えた方が良い。私自身がキース・ヘリングの作品を通じて得たエネル
ギーを、「夢」や「希望」という言葉に置き換えて、そういう若者に伝えていきたい。

ラフィン ／ キースは日記の中で、現世ではニューヨーカーだが、前世では僕は日本
の画家だったと書いています。それを考えると、つまり前世では日本の画家であった
ならば、来世としてキースの作品が小淵沢で生かされていくのも良いのではないか
という気もします。

梁瀬 ／ 先日、クリスティーナさんは、小淵沢の近くの井戸尻遺跡に行って感動され
ていましたよね。井戸尻遺跡は、縄文時代の集落遺跡ですが、確かに、縄文人が残
した芸術性、特に力強さという点ではキースの作品にも同様のものを感じます。

ラフィン ／ バンクーバーの有名な原住民の博物館にあるハイダ族という原住民の
クラフトのものと、井戸尻遺跡で見た縄文時代のカエルやトーテムポールがかなり似
ている部分があって感動しました。さらに驚いたのは、この美術館の庭に続いている
温泉のスパです。

中村 ／ マグマの地熱によって誕生する温泉はエネルギーそのものであり、僕にとっ
ては生命の象徴です。

that elderly women, around 70 or 80 years old, really take to
it. They're the ones who really enjoy it the most. Of course there
are other factors as well; when they come here I think they feel
a sense of release. It's often the case that they come here and
go home very relaxed.

One thing I'd like to try someday is to explore this further,
more scientifically, by comparing elderly Japanese and American
women, grouping them, and seeing how their reactions differ.

In any case, elderly Japanese women are relaxed. They are
used to seeing dōsojin. They have been using mixed gender
baths from a long time ago. They are also well aware of the yobai
culture as a part of traditional culture. They are even familiar with
gay culture. There was also the end of the war and various other
things, and I think that they are very brave and very strong.

L / I think that there is also a difference in religion. When you
look at it in terms of Protestant culture in the Western world, that
kind of sexuality is repressed. He had a strong Catholic influence
from when he was a child, but as a Catholic he was relatively
open. This is a fairly important point, I believe.

Y / I don't think we would be thinking this way about them if
the elderly Japanese women were Christian. Although Keith
didn't believe in Catholicism, because his family was Catholic he
was raised in that culture, and in his diary he writes about the

梁瀬 / スパの設計も、美術館の設計と同様に北川原温氏によるものです。キースが
作ったトーテムポールも、原住民が儀式に使うオブジェに似ていますね。縄文時代
に関しては、館長いかがでしょうか。

中村 / 人類の祖先はアフリカ人だという説があります。そして、今から約1万2千年
前に最初に日本に入ってきて、それが縄文人なのではないかと言われています。
眉や髭が濃い、髭もしゃの縄文人の遺伝子は、北と南、つまり北海道と九州に別れて
います。そして、約2,300年前に北方アジアから眉が薄く、平べったい顔の遺伝子が
入ってきて、それらが私たち日本人のルーツなのではないかと言われています。
　　そういう経緯があるからか、縄文時代の文化は非常にアフリカンアートに似てい
ます。縄文遺跡から、私たち日本人の感性とは違うアフリカンアートに酷似したも
のが出てくるのはこのためです。そして、縄文文化には、四季や自然、宇宙などを意
識したものが多いのですが、キースはアフリカンアートに影響を受けていて
ピラミッドや宇宙船などをとても意識していますね。この共通点に生命力や力強さ
を感じています。
　　日本人のルーツはどこなのか、考古学的には解釈が難しい点があり、色々な説が
飛び交っていますが、サイエンスの側面から言えば、日本の縄文人のルーツはアフリ
カです。これで、縄文文化とアフリカンアートの類似性、キースのアートとの類似性
はこれで紐解くことが出来ると思います。サイエンスとしては実証する作業がまだ
行われていませんが、縄文人が小淵沢に居たという事実なんですね。だからこそ、
この小淵沢にキースの美術館を建てました。

ラフィン / そうですね。原住民のアートはアイコンとして、ものすごくシンプルに
色々なものに取り入れられています。

major dilemmas he faced, what with being gay being a major taboo and having a contract with God and so on.

He said often that he was glad he didn't become like those Catholic families. Those elderly Japanese women didn't have the restrictions that came with religion, had no contract, and in that respect they may have been much more free. Isn't that true of The Tale of Genji as well? That the novel was written by a woman.

L / Anyway, sexuality was a constant theme in his diary.

And, what connects this to what we were talking about is that the conflict. It existed in his work as well. Women who live happy lives do not write interesting things. Likewise with his diary, and why we find it so interesting. It's the great suffering that's interesting after all, although you don't know if [the artist is] suffering in actual life. If you take Michitsuna's mother, for example, she had a very good marriage to someone in a good position, but she's still lamenting. That comes out as one of the themes, but she can't write a story about her happy self. With Keith, too, his work that comes out of his conflicts is what interests us.

N / Although this may have been unfortunate for Keith, I feel that God chose him to leave behind various messages. He painted what was in his head directly without thinking about it. He didn't make drafts. Although what comes out of the paintings he made

36

中村 / アイコンと言えば、『源氏物語』は平安時代のサロン文化から出てくるわけですが、一方では庶民生活の中に道祖神信仰というものが盛んに行われてきました。この道祖神が、またすごいですね、おおらかで。ペニスが巨大化されている道祖神が持つものとキースが描いた性描写、興味深いですね。どちらも明るい描写なのです。

ラフィン / 今朝、美術館でキースの作品を見ましたが、とてもジョイフルなものとしてペニスが描かれていました。実物を見ると、写真なんかで見るよりもっと楽しくなります。猥褻な印象はまったくなく、微笑んでいる自分に気がつきました。

中村 / 人間の根本的な部分だからではないかと思います。この美術館を開設して分かったことは、ご年配の女性、特に70代、80代の方は性的な描写に対して、何の抵抗もなく、すんなり受け入れることができるようです。ここに来て一番楽しんでいるのは、お婆さんたちのように思います。ここに来ると何だか開放されたように、楽しそうな表情をしています。一度日米のお婆さんでどういう反応を示すのかを比較してみたいと思っていますが。

とにかく、日本のお婆さんはのびのびしている。それは、ペニスを巨大化した道祖神も見慣れているし、日常的に混浴に入っている、夜這いという行為が文化として根付いていたなどという、昔からの伝統的な背景があったからだと思います。さらに、ゲイに対しても昔から寛容でした。そして、戦争などの過酷なことも経験していることもあって、日本のお婆さんは相当たくましいですね。

ラフィン / それに加えて、宗教の違いもあるのではないでしょうか。欧米のプロテスタント文化では、そのような性的な部分を排除してきました。一方で、カトリックはオープンな部分があって、子供の頃にカトリックの影響を受けていたキースにとっては、そのことも大きかったのではないかと思います。

are certainly his, I think that he was under the influence of something bigger as well. As it turns out, you see this anguish, these extreme contradictions and suffering in his journals.

L / Right, even a work that's so simple and accessible has behind it a lot of deliberations and distress in his thinking. When I read his diary, I thought that it was really something.

N / Yes, exactly. There's another story regarding Keith that I'd like to share. In 1988 he opened the Pop Shop in Japan, and I had a chance to talk to one of the people who worked there at the time. Apparently Keith went clubbing every night, but wherever he went he was always drawing for anybody, anytime, even in an izakaya bar. The day before he was to leave Japan, as it was his last day they invited him to go clubbing, but he declined. Although it seemed unusual that he didn't want to enjoy his last night out since he had been going to clubs all the time, they just assumed that he was tired. The next day, as they saw him off at the airport, he handed a drawing to each staff member. The night before he left Japan, he had stayed up all night making drawings for each member of the staff, to give to them. When I heard this story the other day, it struck me all over again what an incredibly nice guy he was. *(Laughter)*
The other thing that I can't help thinking is that, to put it somewhat extremely, Japan has been reduced to a culture that

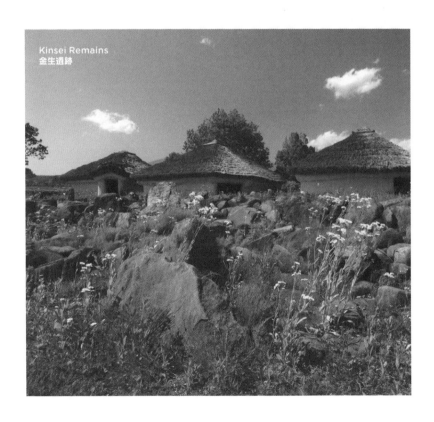

Kinsei Remains
金生遺跡

takes things very lightly and laughs off everything. Of course that makes things easy, but is that really a good thing? I think in reality it might be better for people to sometimes experience hardship, struggle, and from there endure. Today I spoke to a journalist who came here about creating a project that has the capacity to wound. Why is pain necessarily a bad thing? It leads to growth in the future, and it would be good to try to bring out the importance of this. Keith himself suffered greatly...

L / Although when you read his diary you can't help but feel that he's writing it with the reader in mind, he clearly expresses that how to present his works was a big problem that he struggled with. He wanted to succeed very badly, and as he compared himself to other artists he was very eager to come out on top. Ultimately, however, as he achieved more and more success, he began to have many doubts, and he expresses that as his pieces began to sell for larger sums of money that perhaps happiness was to be found in living a simpler life without that kind of money.

N / When he first became a success, he was recognized at clubs and featured in the media, and whenever he went to parties he was a star. However, soon he began to doubt whether that was enough, and if happiness lay elsewhere. Especially after he was diagnosed with AIDS, he began to visit all kinds of places, such as hospitals for children with terminal illnesses. When he discovered

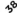

梁瀬 / 日本のお婆さんたちがキリスト教だったら、このような発想にはならなかったと思います。
　キースはカトリックというものを信じてはいませんでしたけれど、家庭環境がそうだったので、必然的にカトリック文化の中で育ちました。もちろんゲイは御法度で、神様との契約を破ることに対して葛藤があったことが日記にも書いてありました。自分はカトリックのファミリーのようにならなくて良かったと、時折口にしているところを見れば、キースにとってのキリスト教は、自由を束縛される堅苦しいものだったのかもしれません。
　日本のお婆さんたちは、宗教という規定はないし、神様との契約もない。だからこそ、自由に振る舞えるのではないでしょうか。日本社会は古くからそうで、だからこそ『源氏物語』が誕生したのではないでしょうか。しかも、女性が書いたという。

ラフィン / キースは、とにかく性に関しては、頻繁に日記に書き綴っていますね。葛藤の中で書いたキースの日記は非常に良い作品でもあると思います。幸せに生きている人で面白いものを書く人はいません。やはり苦労している人の方が面白い。たとえば、『蜻蛉日記』を書いた道綱の母は、良い結婚をして、ポストの高い人と結ばれていても嘆いています。自分の幸せな物語が書けないことが一つのテーマとして出てきます。キースも自分の葛藤の中で描いている作品が我々には面白い。

中村 / キースの人生には悲しさを感じますが、僕は、神が彼に色々なメッセージを残せということで彼を選んでしまったのではないかと思います。彼は下書きをしないところを見ると、自分の頭の中にあるものを、何も考えずに神の指示によって描きまくった。その作品は紛れもなく彼のものであるのだけれど、何かほかの大きなものに動かされて具現化したもののように思うのです。だからこそ、彼の日記には苦悩と矛盾が書き連ねていたのではないでしょうか。

his fate, it was like he discovered and returned to his true self. This is a bit difficult to put into words, but the most important thing to man is that even though I am alive right now, I want and feel the need to continue forever. How to think about something like that is difficult. Should I be hopeful about the future, be pessimistic about the future or whether a future even exists or not? And at times like that, it becomes clear that there are dreams and hopes for the future, that within our universe mankind is wonderful. He began to understand his mortality and that is the message that I feel comes out clearly in his works. Through the collection I want to share that energy and the idea that comes from there.

L / In particular if you read his diary, his desire to live life as fully as he can shines through very clearly. Even before he contracted AIDS, he believed that he would die young and his diary reflects his struggle with the question of how to live his short life.

N / He did drugs. In his works he paints drugs and sex, and the message that "I am not being controlled by drugs, I am not losing myself" is always contained in those works.
 Although he wanted to be in control of himself, somewhere along the way he fell under the control of drugs and violence. The idea that this is really who he is; you could call it a return to humanity.

ラフィン / そう、あのように単純で見やすい作品であっても、その裏でものすごく計画的で計算されていることが分かります。キースの日記を読めば、作品が考え尽くされた上で、作られていることが分かります。

中村 / キースは非常に繊細ですね。キースの繊細さにまつわるエピソードをご紹介すると、彼は88年に日本にポップショップを開きます。その当時、そこで働いていた方からお話を伺いました。
 キースは、クラブが好きで夜な夜な通い、居酒屋も好きで、初対面の方とも気さくに会話し、多くの人と楽しい時間を過ごしました。そして誰にでも、どんな時でも頼まれれば絵を描いていました。最後の夜に打ち上げをするために、スタッフがキースをクラブへ誘ったのですが、キースはその誘いを断りました。最後の夜を楽しむために当然クラブへ行くものだと思っていたスタッフは、キースが体調が悪いと思い心配したそうです。次の日、見送りの空港で、キースはスタッフ一人ひとりにギフトを手渡しました。そのギフトとは、前夜にキースが、スタッフ全員にあげるために朝までかかって描いていた絵だったのです。
 先日、この話を聞いて、キースの繊細さや優しさに感動しました。

ラフィン / 彼の日記を読むと読者を想定して描いていることが手に取るように分かります。彼の作品をどのように見せるのかということが大きなテーマとして書かれていますが、どうしても成功したくて、他のアーティストと比較しながら自分が勝ちたいという気持ちが綴られています。けれど、どんどん成功していくと、今度は疑問を持ち始めるのですよね。こんな値段で自分の作品を買ってもらっても良いのだろうか、本当は貧しいほど、人はシンプルに生きていて幸せなのではないか、ということも書かれています。そこでも葛藤があったのです。

BEST BUDDIES
Silkscreen
66x81.5cm, 1990

40

中村 / 成功すると、クラブでちやほやされて、メディアで取り上げられて、夜な夜な
パーティーに行けばスターだった。自分が望んでいた成功に最初は満足だった。と
ころが、すぐに違和感を持つようになり、幸せというのはもっと違うところにあるの
ではないかという疑念に苛まれるようになった。特に自分がエイズと診断されてか
らは、彼が本来持っている人間性が顕著に現れます。難病の子どもたちの病院な
ど、どこにでも足を運び、子どもたちへの支援活動を始めました。
　自分の運命が分かった時には人間は自分の原点に戻るのですね。人間回帰と言
いますか、これは何なのでしょうか。キースのこの頃の作品からは、人間として一番
大事な生命をずっと継続させたいという思い、人類の生命が続く限り夢や将来がある、
そういうメッセージを感じ取ることができます。自分の命の期限が分かっていて、
ここまでしか生きられないと思えば思うほど、その想いが強く作品に投影されてい
るような気がします。
　死に向かって、逆にどんどん豊かな人間性を養っていくキース。そういう視点で
作品を見るとまた面白いと思います。死を目前にした人間の中に生まれたエネルギー
とその思想を、この美術館を通して大勢の人と分かち合いたいと思っています。

ラフィン / 彼の日記を読むと、エイズになる前でも、自分は若くして死ぬだろうとい
う予言的なことが書かれていて、死に対する意識が高いことが分かります。だから
こそ、短い人生をどう生きていくかということを懸命に考えた、彼の『精一杯生きたい』
という想いが何よりも伝わってきます。

中村 / 彼はドラッグをやりました。作品にドラッグやセックスを描きました。そこに
は常に、そういうものに自分がコントロールされて自分を見失ってはいけないとい
うメッセージがパラドックス的に含まれています。

L / Also, the context has a significant impact on the meaning when looking at a painting. When reading literature from the Heian period, if I don't make a concerted effort to explain that era, it almost becomes meaningless. It's the same with his works. It's important to understand the world he was living in, what kinds of people he was working with at the time, and what kinds of problems he was facing. Then, with Keith as an intermediary, I think it's great if people can look through that medium and interpret it in their own ways. Much like everyone has their own interpretation of The Tale of Genji, I think it's great if everyone can come up with their own interpretation of Keith.

N / Japan is a very different place from New York with a very different cultural background. It is only natural that when Japanese people try to understand Keith that they attempt to grasp what is really behind the works. That's why our goal is to continue to evolve this museum and spread the message for the next 50 years, 100 years, even longer. Although I don't know how it will change, I sincerely hope that it will last forever.

Conversation
Christiana Laffin (The University of British Columbia, Assistant Professor of Asian Studies) Kazuo Nakamura (the Nakamura Keith Haring Collection, Director); "Keith Haring and Japanese Culture." Moderator: Kaoru Yanase (the Nakamura Keith Haring Collection Advisor; International Association of Art Critics Member) Saturday, September 19, 2009, the Nakamura Keith Haring Collection outdoor courtyard

ラフィン / 絵を見るには意味があります。平安の文学を読む時に一生懸命その時代を理解するのと同じように、キースの作品を見るにも、どういう世界の中で生きていたのか、どういう人たちと付き合っていたのか、どのような問題と向き合っていたのかなどを考えないと、意味を持たないですね。そのとき、それぞれの人が自分なりの解釈を持つようにすれば良いと思います。人それぞれの源氏解釈があるように、人それぞれのキース解釈が出来れば良いと思います。

中村 / ニューヨークではなくこの日本で、まったく違う文化を持つ日本人がキースを理解しようとしているのですから、当然、作品の捉え方も違うわけです。この地から放つキースのメッセージを多くの人に感じてほしい。だからこそ、僕たちはこの美術館をどんどん進化させ、メッセージを発信し続けたいと思っています。50年後も100年後も。

座談会
クリスティーナ・ラフィン(ブリティッシュ・コロンビア大学アジア研究助教授)×中村和男(中村キース・ヘリング美術館 館長) [モデレーター] 梁瀬薫(中村キース・ヘリング美術館 顧問 / 国際美術評論家連盟 会員) 2009年9月19日(土) 中村キース・ヘリング美術館 野外パーティーコート

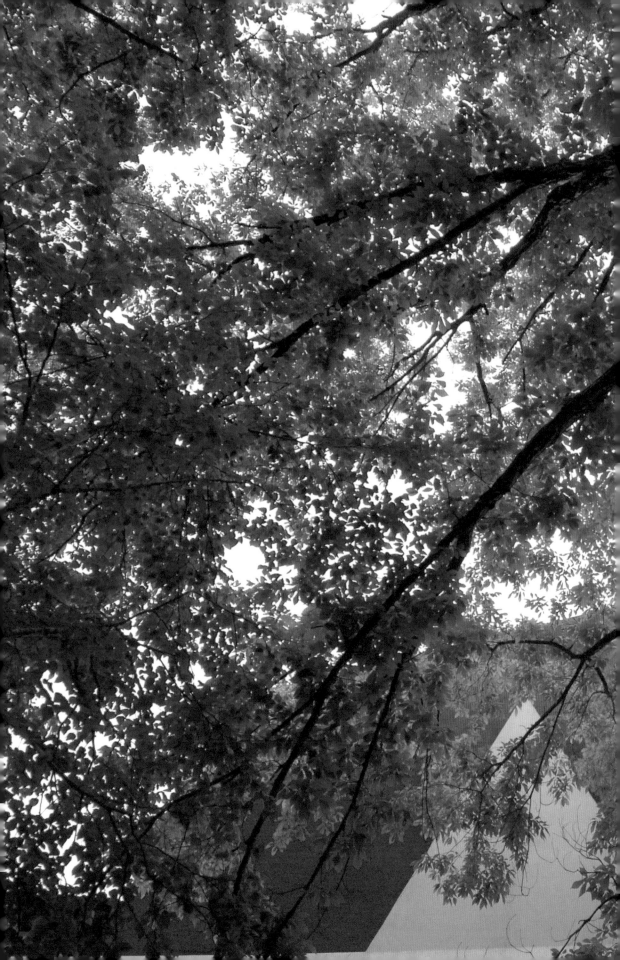

44

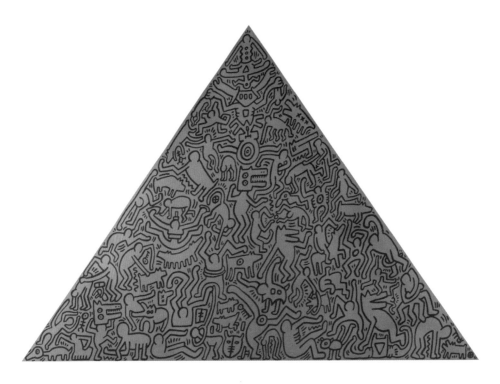

PYRAMID
Silkscreen on metal
144.8x103cm, 1989

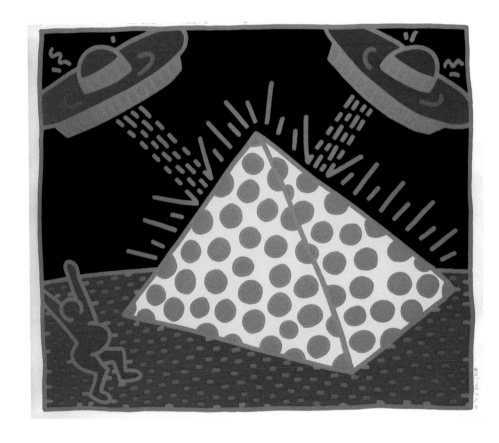

UNTITLED (FERTILITY)
Silkscreen on paper
106x127cm, 1983

46

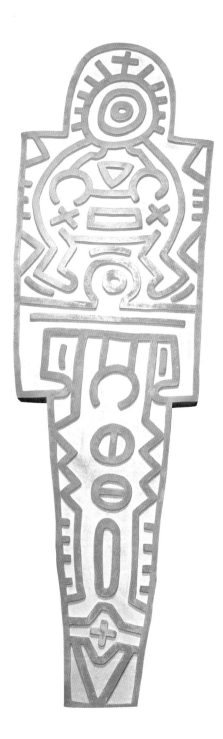

UNTITLED (HARING TOTEM POLE)
Concrete
108.7x55.5cm, 1989

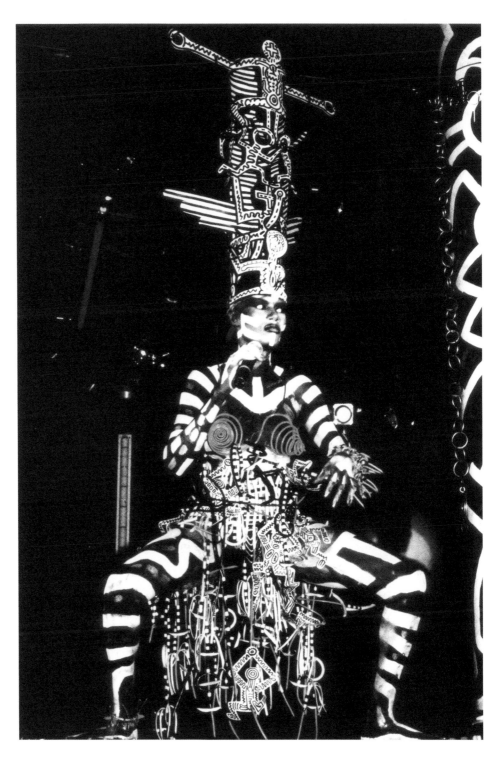

47

Grace Jones body painting with Keith Haring, 1984

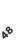

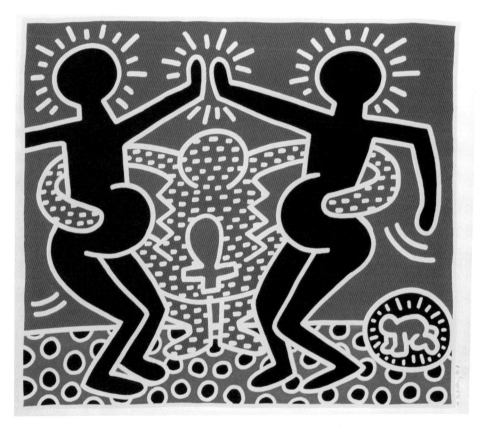

UNTITLED (FERTILITY)
Silkscreen on paper
106x127cm, 1983

UNTITLED (FERTILITY)
Silkscreen on paper
106x127cm, 1983

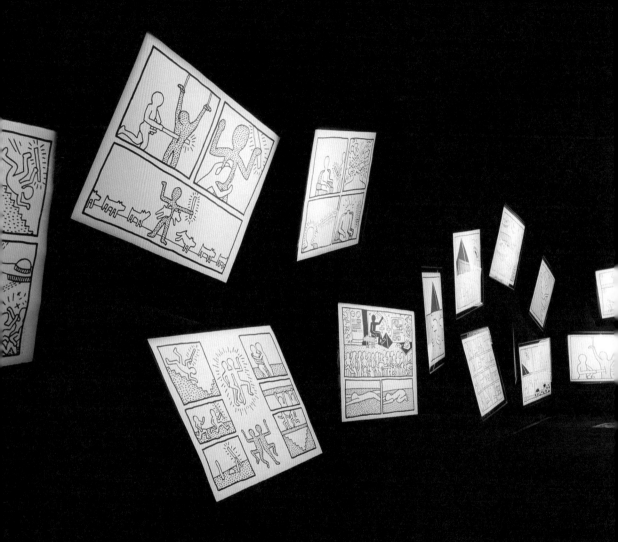

"Dark" Gallery

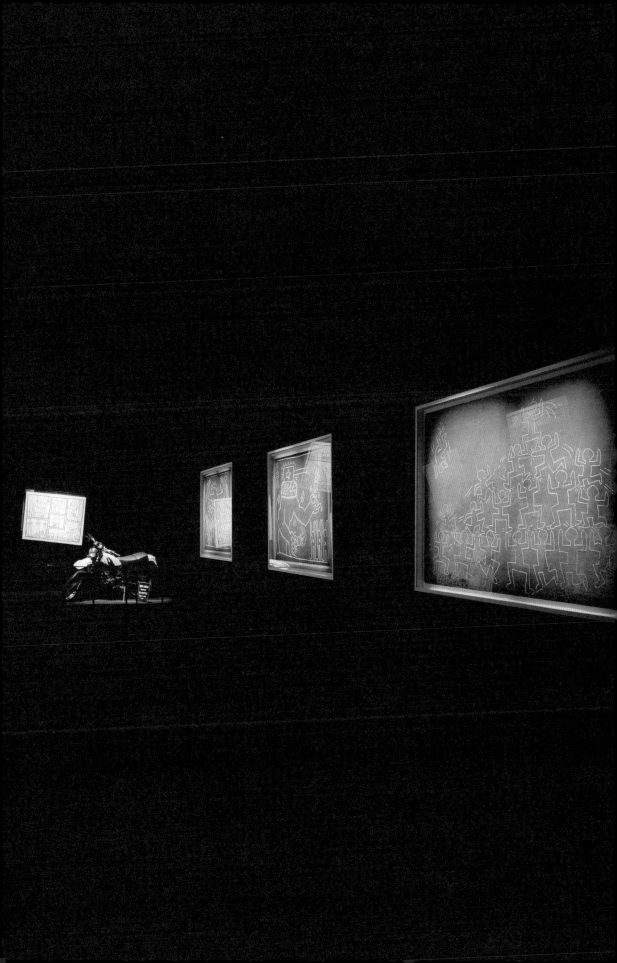

Yutaka Mikami

三上豊

Keith
into
Nature
キースを森に放つ

In late summer of 2009, a gentle sunlight is casting a shadow of
a Japanese oak over the gallery wall. Tunes of electric trumpet played by
Toshinori Kondō are racing the grounds. Kazuma Glen, a young performer
visiting from New York, is dancing over the grass in samurai attire.
Kazuo Nakamura, the director of the Nakamura Keith Haring Collection,
is lying down, gazing at the sky as if confirming the feeling of "the
unconquered sprit." This is a scene from the summer event "Ecté."

Kobuchizawa: At the Foot of the Yatsugatake Mountains

The museum is located in Hokuto, Yamanashi Prefecture. It takes two hours
from Shinjuku by a Chūō Line limited express. Kobuchizawa station is our
destination. Situated 1000m over sea level, its air, unlike Tokyo, is refreshing.
Let's first go around the station neighborhood. The entire area at the foot
of the Yatsugatake Mountains is a summer escape and a tourist destination.
In winter, temperatures drop significantly and the harsh environment compels
the library to close. Just like in many tourist places, the residents make their
way museum mainly by car, and one can hardly see a pedestrian. From the
station it takes a few minutes by car along a straight road that is most likely
a result of the post-war development. On both sides of the road stretches
a forest of cedar, larch, and Japanese oak. Speaking of roads, the trail, which
was developed by General Takeda Shingen in the Sengoku period (1467-1573)
at the outset of the war, also creeps deep into the forest. The end of such
a narrow road is dotted with small stone shrines and Buddhist statues.

Kobuchizawa is surrounded by remains from the Jōmon period
(ca. 10,000 BC—ca. 300 BC). It is an area that can be traced back 5000 years

54

２００９年晩夏、柔らかな日差しが、美術館の壁に楢の木の影を落としていた。近藤等則が奏でる
エレクトリック・トランペットの音が、地面を滑るように駆けていた。ニューヨークからやって来た若
きパフォーマー、カズマ・グレンは、侍のような出で立ちで芝生の上で舞い踊る。館長の中村和男は横
になり、「生をつかまえにいく」感覚を確かめているかのように空を見つめている。中村キース・ヘリ
ング美術館、夏の催し「エクテ（木霊）」のワンシーンである。

小淵沢、八ヶ岳の麓

美術館は山梨県北杜市にある。新宿から中央本線の特急で２時間あまり、下車駅は小淵沢。標高
１千メートル、空気は都心とは違いさわやかだ。駅周辺をまずめぐってみよう。八ヶ岳の麓のこの辺
り一帯は、夏の避暑地であり観光地でもある。冬は極寒となり、美術館も休館するほどの厳しい環
境につつまれる。観光客の多くと同じように住民の脚はほとんどが車で、歩いている人を見かけるこ
とはめったにない。駅から美術館までは車で数分だが、その道は戦後の開拓のなごりか直線状に整
備されたようだ。道の両側には杉やカラ松、楢といった木が繁る森が広がる。道といえば、戦国武将
武田信玄が戦の際に切り開いたと伝わる「棒道」も森の斜面にはうようにある。こうした森の小道の
端はしには、小さな石の祠や石仏が点在している。

さらに小淵沢周辺には縄文遺跡が多くある。縄文中期、現代から古代人の生活をほぼ５千年前に
さかのぼることができる土地なのだ。美術館から車で数分の井戸尻考古館に展示された縄文時代の
石の工作具や槌、焼成された深鉢、器物に装飾された小動物や天体は、見る者を遥か古代の風景へ
引き込んでいく。縄文土器は素朴とも言われるが、かなり高度な文化であったことが見えてくる。

しかし、こうした縄文文化は考古資料として貴重であることは当然だが、芸術として見直されたの
は戦後であり、画家の岡本太郎や詩人の宗左近といった前衛的な芸術家たちによって再発見された
といっていい。彼らは古代の造形力を、そのダイナミズムを称えた。

また、小淵沢を最北端として、甲府周辺には民間信仰のひとつでもある「丸石神」が数多く路傍に
置かれている。この丸い石の神様は、村の境界（死と生の境界でもあるのだが）を示す道祖神とも
いわれるが、単純に丸い石がどうして神様になっているのかはわからない。とはいえ、球という絶対

into the mid-Jōmon period. Stone construction tools and hammers, fired pots, containers with painted small animals and heavenly bodies displayed at the Idojiri Archeological museum, only a few minutes away from the Collection, take visitors into the ancient era. Although the Jōmon earthenware is considered simple, it reveals a considerably advanced culture.

Such Jōmon culture is naturally regarded a valuable archeological source, but it also came to be viewed as art after the war when it was rediscovered by avant-garde artists, such as the painter Tarō Okamoto and the poet Sakon Sō. They were fascinated with the creative power and dynamism of ancient times.

Furthermore, with Kobuchizawa as the farthest north, Maruishigami (round stone deities), one of the folk beliefs in the Kōfu area, are scattered along the road. These round stone deities are viewed as traveler's guardian deities who mark the boundary between the villages (and between life and death), but it is unclear how these round stones came to be considered gods.

Yet, certainly the sphere as an absolutely abstract form evokes something universal. It seems that for these round stones scattered here and there, diversity is preferred to centrality (in the sense of growing in importance). So far we came to discuss Kobuchizawa area in terms of its forests, Jōmon culture, and Maruishigami. That the works of Keith Haring have been dropped in such an environment reveals one of the directions of the gallery.

As a collector of Keith Haring, Kazuo Nakamura, is now recognized and well regarded by art dealers from America and Europe, but he is mainly known as a venture entrepreneur in the pharmaceutical industries. When he traveled around the world on business, he got enchanted by Keith's work when he suddenly saw it on a street in New York. What Nakamura found in Keith twenty years ago was

的な抽象形体はそれだけで普遍的ななにかを私たちに意識させることは確かだ。この丸石は、あちらこちらに点在することで、中心性―つまり神としてどんどん偉くなることよりも、多様性を重んじているようにみえるのだ。

　ここで、小淵沢の地域性から見いだされたことを確認しておこう。「森」と「縄文文化」と「丸石神」だ。このなかにキース・ヘリングを投げ込むことが、中村キース・ヘリング美術館の方向性のひとつでもある。

　美術館館長中村和男は、いまでこそキース・ヘリングのコレクターとしてアメリカやヨーロッパのアートディーラーたちからも一目を置かれているが、本業は薬品関連のベンチャー起業家として知られている人物である。彼が仕事で世界を駆け巡っていたとき、ニューヨークの街角で、ふと目にし、引き込まれたのが、キースの作品だった。20年以上前に、中村がキースに見たもの、それは造形がもつ初原的なエネルギーだった。いや、造形というよりも、初見で感じたのは、キースの作品が発する熱いものであっただろう。今日に至るまで、中村はキースの作品を収集してきた。収蔵作品は現代アートにおけるキースの位置、美術市場、美術館やコレクターの評価をもって、十分査定できるところまできた。

　これから、中村がキースの作品に出会った、ニューヨーク1987年12月28日、その初見での衝撃を、小淵沢の地で考えてみたい。

縄文文化

　美術家岡本太郎は、戦後日本の前衛美術をリードした人物であり、戦後間もなく東京国立博物館で縄文土器と出合う。岡本は、戦前フランス留学の体験をもち、シュルレアリスムを主とした前衛美術を吸収すると同時に、マルセル・モースから民俗学を学び、古代の造形ついても幅広く知識をもっていた。彼は縄文土器について次のように語っている。

　「縄文土器のもっとも大きな特徴である流線紋は、はげしく、するどく、縦横に奔放に躍動し、くりひろげられます。その線をたどってゆくと、もつれて解け、混沌に沈み、忽然と現れ、あらゆるアクシデントをくぐりぬけて、無限に回帰しのがれてゆく。(略) さらに、異様な衝撃を感じさせるのは

the primitive energy of the forms. In fact, rather than forms, what he first felt was the heat that Keith's art emits. Ever since, Nakamura has been collecting Keith's work. The items in the collection have reached a level at which the place that Keith occupies in contemporary art and on art market, as well as its value for galleries and collectors, can be assessed adequately.

Now let's reflect on the impact that Keith's work must have had on Nakamura that very first time, on December 28th, 1987, by considering the location of Kobuchizawa.

Jōmon Culture

Painter Tarō Okamoto is a leading figure in the post-war avant-gardism in Japan, who soon after the end of the war encountered Jōmon earthenware in Tokyo National Museum. Prior to the war, Okamoto studied in France, absorbing mostly surrealist avant-garde art and studying folklore under Marcel Mauss. He was broadly familiar with ancient forms. This is what he says about Jōmon earthenware:

The streamline design, the main feature of Jōmon earthenware, runs intensely, sharply and wildly in all directions and unfolds before the eyes. The lines entwine and untie, sink into chaos, emerge suddenly, slip through each collision, recur inexhaustibly, and flee. Moreover, what causes this strange impact is the incredible asymmetry of the forms as a whole. It is a broken meter, dynamism. This expression constantly pushes the limits.
Okamoto, p. 37

その形態全体のとうてい信じることもできないアシンメトリー（左右不均斉）です。それは破調であり、ダイナミズムです。その表情はつねに限界を突きやぶって躍動します」（岡本 37ページ）。

この文脈にキースの作品を重ね合わせると、同調すべきリズムを覚えないだろうか。「奔放に躍動」「回帰しのがれて」「ダイナミズム」「限界を突きやぶる」―私たちがキースの作品を前にしたとき感じる、ユーモアや暴力性、リズム感を岡本は言い当てているともいえよう。

中村が直感的に縄文のあった土地にキースを導くこと、それは呪術にも似た感覚ではなかっただろうか。サイエンティストである彼からすれば、お門違いの指摘かもしれないが、そもそも彼の故郷が小淵沢の近くであり、幼少年期をよくここで過ごしたことが、偶然とはいえ、美術館設営のきっかけとなっている。岡本太郎の縄文土器への考察は、２００７年、小淵沢の地でキースの作品と交差したのだ。

また、キース自身も次のようなことを言っている。

「プリミティヴでポップなものにぼくはものすごく関心があったし、ぼくのドローイングのスタイルはエスキモーやアフリカン、マヤ、それにあのアボリジニーのアートにとても近い」（グルーエン 133ページ）。

プリミティヴを未開とか原始といった本来の意味でなく、プリミティヴ・ポップとして、私たちが現在ももつ呪術性への親和力を、キースと縄文に感応できるのではないだろうか。それがあるからこそ、それまでアートとはほとんど無縁だったサイエンティスト中村の心を開いたのだ。

丸石神

キース・ヘリングは、１９８１年、地下鉄のグラフィティーで注目を集め、それ以後もつねに大衆のなかのアートを模索し続けた。特権的なハイカルチャーに取り込まれることよりも、アート・ワールドの外側に自分を置くことに執着していたといえよう。しかしながら現在では、彼の作品は市場価値をもち、高額な値段で売買されているわけだが、一鑑賞者からすれば、そういった面は画商やコレクターの問題であって、キースについて考えるときには、まずキースの作品の前に立ち、向き合い、語りかければいい。

日本でのポップショップの失敗について、キースは「偽物の氾濫」をあげていた。しかし、彼の作風

When you position Keith's work in this context, don't you feel a synchronous rhythm? "Running wildly," "recur and flee," "dynamism," "pushing the limits"—it is the humour and the violence, the rhythm, which one feels when facing Keith's work that Okamoto had in mind.

The fact that Nakamura instinctively brought Keith into the land of Jōmon culture appears like a kind of a spell. This may seem an incorrect remark, but for a scientist the facts that his native place is near Kobuchizawa and he frequently visited the area as a child, naturally becomes a lead as to why he set up a gallery here. Tarō Okamoto's observations about Jōmon earthenware intersected with Keith's work in Kobuchizawa in 2007.

Keith himself says the following:
I was really interested in primitive and pop, and my drawing style is close to the arts of the Eskimos, Africans, Mayas, and even Aboriginal.
– Gruen, p. 133

"Primitive" not in the sense of "undeveloped" or "archaic" but as primitive pop, is likely to relate our affinity to spells, even in the present, to Keith and Jōmon culture. This is precisely what opened Nakamura's heart, who as a scientist had been indifferent to art.

Maruishi Gami

In 1981 Keith Haring attracted attention with his subway graffiti, and since then continued to explore the possibilities of producing art among the public. Rather than moving into the privileged high culture, he can be viewed as being

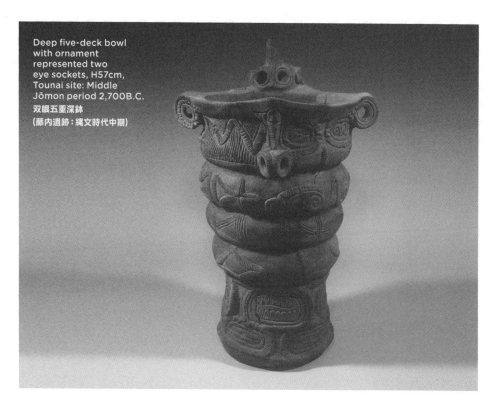

Deep five-deck bowl
with ornament
represented two
eye sockets, H57cm,
Tounai site: Middle
Jōmon period 2,700B.C.
双眼五重深鉢
(藤内遺跡：縄文時代中期)

attached to the outside of the world of art. Nonetheless, his works have a market value and sell highly at the present, but to a viewer such aspects remain matters for art dealers and collectors. Thus, to appreciate Keith, one should first stand in front of his works and try to speak to them.

Regarding the failure of popshop in Japan, Keith provided "a flood of fake prints." However, his style was doomed to propagate like regenerating cell segments. Before it was acknowledged as art, people discovered him even in objects of no authenticity. The producer's autograph (signature) is important for giving value to his/her works, and for proving authenticity. However, Keith's art challenges the system of modern art galleries, even with regard to the signature acting as a certificate. Because it had that power, imitations of his works flooded the market in the past, and even now a large number of goods are produced under the control of the foundation.

One of Keith's symbolic forms is "Radiant Baby" which can be called a tag. Like the popular Japanese crawling baby toy and the baby remained by his side throughout his life, he was reported to have been trying to draw a baby two days before his death. As suggested by the sticker that read "God is dog," "the more he drew [this four-pawed figure] the more it came to resemble a baby." *(Gruen, p. 84).* The baby, whose sex is indistinguishable, is a prototype of the human figure. A round face, crawling pose, no eyes nor nose, and yet the whole body looks as if laughing because of the straight lines that radiate in all directions. The torso and limbs that grow out of a flat face evoke a round stone deity to which hands and legs were attached. The baby goes everywhere crawling.

"Less is more" may be an overstatement, but Radiant Baby can be considered

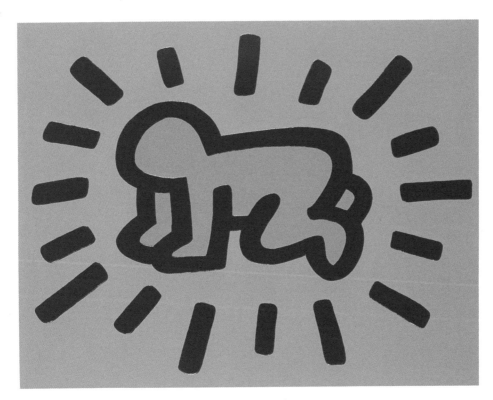

UNTITLED (RADIANT BABY FROM ICONS SERIES)
Silkscreen on paper
53.34x63.5cm, 1990

a form of Keith's minimalism. Keith's drawings stand out for the simple lines. Radiant Baby, which was drawn several thousand times was not a work made by order as is typical for minimal art. It is something that Keith drew by hand throughout his life. It slips away from limited art centered on the image of the author, from high art, and even from Keith's hands, due to its simplicity and popularity.

The perception of such escape can be applied to the Maruishi Gami too. These round stone deities defy culture and anti-culture. Naturally regarded as a local folk belief, Maruishi Gami can be approached similarly to the way of considering Jōmon earthenware from a modern point of view. Shin'ichi Nakanishi, a scholar of religion and native of Kōfu Prefecture, once commented on the round stone deities in the following way:

> Maruishi are not metaphors or imitations of concepts, but simply a sensuous abstraction of the universal rhythm and breath.
> – *Nakazawa, p. 180*
> When viewing the round stones as forms in which the Gestalt becomes visible, they can be interpreted as transcended consciousness (heart) that has taken the invisible shape of universal rhythm and breath.
> – *Ibid., p. 182*

Maruishi gami give birth to an emptiness within general culture, and distance themselves from the "centre and periphery" principle of fixed culture. In every moment there is a strong interaction among each of the stones, and as a total result each gives birth to self-generation that becomes the principle" *(Ibid., p. 184)* and does not belong to any culture, thus preserving the style of non-culture.

は細胞が分裂するかのように増殖していく宿命を背負っていた。彼がアートとして認知する以前に、人々は本物でないものにもキースを見いだしてしまった。作家としての刻印（サイン）は、作品を価値付け、証明するものとして重要なことだろう。それでも、サインといった保証書のような、近現代美術につきものの制度さえも、キースのアートは打ち破ってしまったのではないか。そのパワーがあったがゆえに、過去には偽物が氾濫し、また現在でも数多くのグッズが財団の管理のもと制作されている。

キースのシンボル的な造形に、タグといってもいいだろう、ラディアント・ベイビーがある。俗にハイハイベイビーといわれるが、彼は死ぬ2日前にもベイビーを描こうとしていたといわれ、終生彼の側にいた。犬のタグは「神は犬だ」と書いてあった張り紙がヒントという指摘もあったが、この四つんばいの人物、「描けば描くほど赤ん坊に似てきた」（グルーエン84ページ）という。性別もない赤ん坊の姿は、人間と人物像の原型だ。このラディアント・ベイビーには目鼻がない。丸い頭にハイハイのポーズ、目も口もないが光を示す棒線が放射状にあることで、全身で笑っているようだ。のっぺらぼうな顔に生えた胴体と手足は、丸石神に手足、胴体がついたかのようだ。ベイビーはどこへでもハイハイして行く。

レス・イズ・モアというと言い過ぎかもしれないが、ラディアント・ベイビーはキース的なミニマリズムの形象かとも思える。シンプルな線はキースのドローイングの特徴でもある。何千と描いてきたラディアント・ベイビーは、ミニマル・アートにありがちな発注作品ではない。キースが生涯にわたり、手で描いてきたものだ。シンプル故、大衆的故に、作家性といった狭いアートからも、特権的なアートからも、またキースの手の内からもハイハイして脱走してしまうのだ。

この遁走の感覚は、丸石神にもまたいえることだ。丸石神は文化、反文化といった文脈からするりと抜け出していく。前提として地方に残る民間信仰と捉える視点は当然だが、丸石神も縄文土器を現代の人々がみるような視点で捉えてみよう。

甲府出身の宗教学者中沢新一は、かつて丸石神を次のように述べている。

「丸石は、なにかの意味の隠喩であったり、観念を模倣するものでなく、宇宙的なリズム、呼吸とでも呼ぶべきものの感覚的な抽象化にほかならないのである」（中沢180ページ）。

「知覚のゲシュタルトが見える形としての丸石をとらえるとき、意識（こころ）はそれを越えて宇宙

Keith's Radiant Baby is a human figure in the process of creation and a neutral form. To the viewer, this form with no belonging appears as a product of each interaction. The meaning that is born is not positioned within a system from the past, and constantly generates itself and also undergoes transformations. Radiant Baby's form differs from the forms produced by any other art. It is neither anti-art, fine art, nor popular art, but non-art, unevenly distributed in free places. Whether in the subway or on city streets, in exhibitions or galleries, Keith's art leaves its footprints deep into each viewer, like a tattoo. Radiant Baby, like a sibling of the round stone deities, fully qualifies for Kobuchizawa's area.

A Museum in the Woods

It is the architect Atsushi Kitagawara who was entrusted with the task to propose how to exhibit Keith's work. In the beginning, Kitagawara came up with an idea to make a display space in Kobuchizawa's nature like a huge zigzag-shaped cavern with tunnels intersecting within. However, when he learned about the large number of the items in the collection, which exceeded two hundred, he created the "Darkness and Desire" Complex in attempt to pursue Keith's life.

Let's go around the present galleries. As you exit the passage of the forest, you get to a round stone at the entrance. (One wonders whether it is related to Maruishi Gami.) A round stone in front of a building is thought to signify entrance prohibition, and considered a sign of boundary. From the entrance one is to walk down a dark slope, like in a subway. Then comes the "Gallery of Darkness" where Blueprint Drawings and one of the highlights of the collection, the motorcycle, is located and spotlighted.

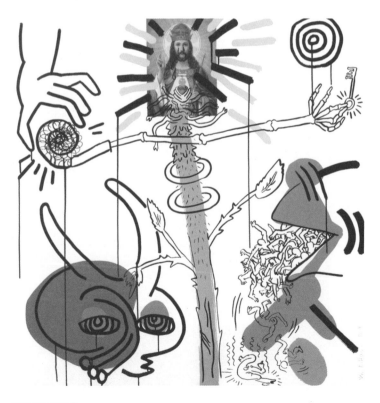

APOCALYPSE
Collaboration with William Burroughs
Silkscreen on paper
96.5x96.5cm, 1988

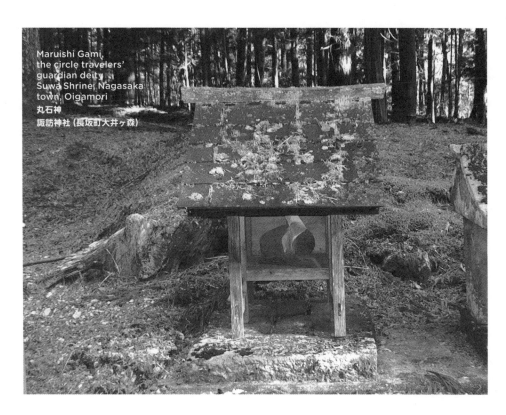

Maruishi Gami,
the circle travelers'
guardian deity
Suwa Shrine, Nagasaka
town, Oigamori
丸石神
諏訪神社（長坂町大井ヶ森）

のリズム・息という見えないかたちをとらえていたはずなのだ」（同182ページ）。

　丸石神は、一般文化のなかではある空虚をうみだし、中心やその周辺といった固定的な文化の原理から離れ、「各瞬間に各人の間の強い相互作用が働き合って、その結果の総体が自分自身をうみだしていくような自己成性が原理となって」（同184ページ）おり、どんな文化にも属さず、非文化のスタイルをまもっているという。

　キースのラディアント・ベイビーとは、生成過程にある人物像であり、中性的な形象である。帰属性のない形は、見る者にとってそれぞれの相互作用として成立するしかない。立ち上がってくる意味は過去の体系に位置づけられるのでなく、常に生成していくなかで変容していく。ラディアント・ベイビーは、これまでのアートが生み出したどんな形象ともちがい、アンチアートでもなく、ファインアートでもなく、ポピュラーアートでもなく、すべてから自由なところに偏在する非アートなのだ。地下鉄や都市の街角、画廊や美術館にあっても、見る者一人一人の深層に、タトゥーのように印されていくのがキース・アートなのだ。

　ラディアント・ベイビーが、丸石神の兄弟として小淵沢にあることの資格は充分にあるのではないだろうか。

森の中の美術館

　実際にキースの作品をどう展示するか、任を託されたのは建築家北川原温だ。北川原は当初、小淵沢の自然のなかに巨大な洞窟、キースのグラフィティーのようにジグザグした、内部で交差するトンネルのような展示空間を考えていた。しかし、200点以上あるコレクションの内容を知るにつけ、さらにキースの生涯を追ってみるうちに、「闇と希望」というコンセプトに辿りつく。

　現在の美術館をめぐってみる。森の散策路を抜けると、入口には丸石神と関係があるのか、丸い石がある。丸石を建物の前におくことは、入ることを禁止する意味もあるそうだが、境界としての印といえよう。入口からは下りの暗いスロープを歩くことになる。地下鉄の空間か。ブルードローイングや版画、コレクションの目玉といえるオートバイがある「闇の展示室」は黒い壁面であり、スポットが作品を照らす。

In addition, what fascinates the viewers most of all is the enormous space called "Display Room of Desire." The suspended ceiling is 13 meters high with an enormous sculpture "Untitled: Two Dancing Figures" and a painting displayed under the direct illumination accumulated from the sun. The painting "Untitled: People" which layers grown-up Radiant Babies, has chaotic and dynamic emotions and is regarded as Keith's representative work. Someone once called this room a "bright La Chapelle de Ronchamp." The gallery, when explored inside, emerges as different from the ordinary vertical and horizontal architectural space, and due to the slopes and curves that stand out, it makes one aware of circles, squares, and triangles. What such forms represent is perhaps what is often called "circle=infinity," "square=perfection," "triangle=aspiration."

As you exit the display room, there is gravel spreading all over, a black plank wall surrounding the museum court, and a sculpture of a red doll "Untitled: A skating figure shaped as a circle." When you stand in the court you realize that this gallery is a contemporary shrine. The building, like a large cone upside down, the roof with abnormal design because of the tiles, is constructed in a tricky shape. What makes each part stand out is the play of colors. A combination of red, black, and white meets your gaze in every direction.

Black, that appears as a result of almost full absorption of the visible rays of light, white, that is produced when the visible rays are reflected, and red,that is considered fundamental for humanity—red is blood, and in the Jōmon era it was made by mixing lacquer and red ochre and had a wide range of use, from earthenware to burials. The three fundamental colors are sacred components of rituals. They are indispensable for a shrine.

62

そして、なによりも見る者を驚嘆させるのは、「希望の展示室」といわれる巨大な空間だ。懸垂曲線による垂れ下がった天井は高さ13メートル、日の出の照度に保たれた間接照明のもとに、巨大な彫刻《無題（踊る二人のフィギュア）》と絵画が展示されている。絵画《無題（ピープル）》は、成長したラディアント・ベイビーが幾重にも重なり、カオス的でダイナミックな表情をもち、キースの代表作といえる。ある人はこの部屋を「明るいロンシャンの教会堂」といった。館内をめぐっていると、垂直や水平といった普通の建築空間からの印象とはちがい、斜面や曲面が際立つゆえに「円や四角、三角」を意識させられる。そうした形が表徴するのは、よく言われる「円＝無限、四角＝完全、三角＝抱負」のことかもしれない。

展示室を出ると白い玉砂利が敷き詰められ、黒い板塀で囲まれたたミュージアムコートには、赤い人型の彫刻《無題（輪になった人物のフィギュア）》がある。

そのコートに立った時、この美術館は現代的神社なのだと実感した。建物は逆円錐の大きなヴォリューム、タイルによる変則的な模様をもつ屋根など、トリッキーな形で構成されている。そうした各部を際立たせているのが施された色彩である。どこを見ても赤と黒と白の組み合わせからなりたっているのだ。

可視光線をほとんど吸収することで現われる黒、可視光線を反射するときに現われる白、そして人類にとって根源的ともいわれる赤色、赤は血であり、縄文時代、漆液にベンガラを混ぜることでできた朱は、土器をはじめ埋葬物に使用されている。3つの根源的な色は、祭祀に使われる聖なる要素である。神社につきものの色なのだ。

北川原温は、美術館を小淵沢の森にグラフィティーとして描いた。たとえ建物の異様さに来館者が違和感を覚えたとしても、時間がたつにつれ、ハレの空間、祝祭的な時空間を肌でもって感じることができる場としてある。おそらく来館者はここを訪ねた時、「闇」と「希望」と同じくらいに、森とこの現代的神社によって、自然に自らをゆだねる、解放されるような感覚をもつだろう。都心でも神社の側には森の名残をみせる巨大な樹木がそびえている。同じように、美術館の前面と後面には大きな楢の木が一本づつ聳えている。そもそも森とは、神が降りてくるところであり、母型としての意味合いをもっている空間である。そうした森はミステリアス（闇）であると同時に自由や解放（希

Atsushi Kitagawara created the gallery like graffiti in the forest. Even if the building strikes visitors as incongruous, with the passage of time it allows a first-hand experience of the celebratory space.

Just like "darkness" and "desire," the forest and this contemporary shrine enables visitors to give themselves in to the nature and get a feeling of liberation. Even in city centers tall trees rise by shrines. Likewise, there tower big oak trees, each in front and behind the gallery. After all, a forest is a place where deities descend; it is a space that functions as a matrix. A forest has two faces: a space of mystery (darkness), and freedom and liberation (desire). Though it sounds too good to be true, the gallery also has a spa that encourages the liberation of the spirit.

Keith Haring was active as an artist in the 80's and has come to depict New York's thrilling art scene. Now in Kobuchizawa, Japan, he continues his work as "universal rhythm" that liberates us constantly.

Late fall, the leaves of the trees no longer change their colors, and the gallery is about to face a cold winter. Silence visits the gallery shrugged between the two large Japanese oaks. It is probably the time of death when everything stops. However, this precisely is the time to accumulate energy for "the unconquerable spirit." Nakamura Keith Haring Collection's life goes on inside the forest.

Reference
Okamoto, Tarō, *Okamoto Tarō Book Series 4* (Kōdansha, 1979)
Gruen, John, *Keith Haring*, translated by Kinoshita Tetsuo (Libroport, 1992)
Nakazawa, Shin'ichi, 'Maruishi no oshie' in: *Maruishi Gami*, edited by Maruishi Research Group (Mokujisha, 1980)

望）の空間といった両義的な顔をもっている。できすぎのようだが美術館には心身の開放を手助けするためにスパも併設されている。

　キース・ヘリングは、80年代のアメリカのアーティストとして活躍し、スリリングなニューヨークのアートとして語られてきている。いま日本の小淵沢で、キースは森のなかで、私たちを常に解放する「宇宙のリズム」として躍動しているのだ。

　晩秋、樹々の紅葉も終わり、美術館は厳しい冬の季節を迎えようとしていた。2本の大きな楢の木に挟まれた美術館には静寂が訪れている。すべてが停止してしまう死の時間帯かもしれない。だが、この時間こそ、「生をつかまえにいく」エネルギーを蓄積する時間でもある。中村キース・ヘリング美術館は、森の中に生き続けているのだ。

注
『岡本太郎著作集4　日本の伝統』講談社 1979
ジョン・グルーエン『キース・ヘリング』木下哲夫訳 リブロポート 1992
中沢新一「丸石の教え」『丸石神』所収 丸石調査グループ編 木耳社 1980

UNTITLED (SUBWAY DRAWINGS)
White chalk on billboard
121.9x182.9cm, 1982

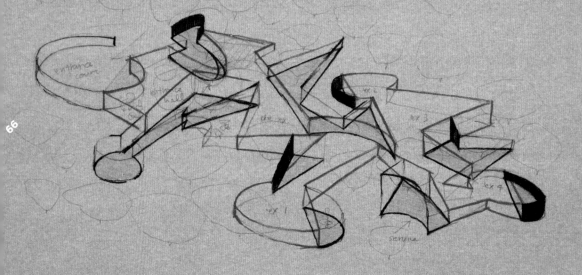

Study drawings by
Atsushi Kitagawara

 miusi k

Kerh Hory M.

miusi k

miusi k

Projects
in
Japan
日本での活動

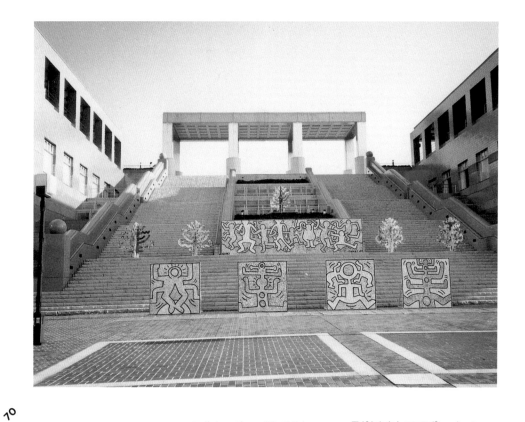

70

Collaborating with Children

In October 1987, he held a workshop with children in the outer area of Tokyo, in Tama City. The event helped commemorate the opening of the Tama City Combined Cultural Center (Parthenon Tama), which was constructed as a palace of art in Tama New Town—the largest housing development of postwar Japan. Several hundred children between the ages of 6 and 8 gathered in the outdoor event space. Keith's human figures were painted on six panels, and the children used them as the base to create their own drawings. Another project was called the Sound-Fruit-Project: wooden objects were designed by Keith, upon which children hung their hand-painted bells, everyone contributing their prayers for peace. This work is currently owned by the Tama City Cultural Foundation.

子どもたちとのコラボレーション

１９８７年10月、都下多摩市で子どもたちとのワークショップを行う。戦後日本最大規模の都市計画、多摩ニュータウン、文化の殿堂として建設された多摩市立文化複合施設《パルテノン多摩》の開館記念として開催された。屋外会場には６歳から８歳までの子どもたち数百名が集まった。６枚のパネルに描かれたキースの人型を基調に、子どもたちが思い思いに作画していった。またサウンド・フルーツ・プロジェクトと題し平和の祈りを込めて、キースがデザインした木のオブジェに、子どもたちが彩色した鈴が自由に吊り下げられた。このときの作品は現在、財団法人多摩市文化振興財団に所蔵されている。

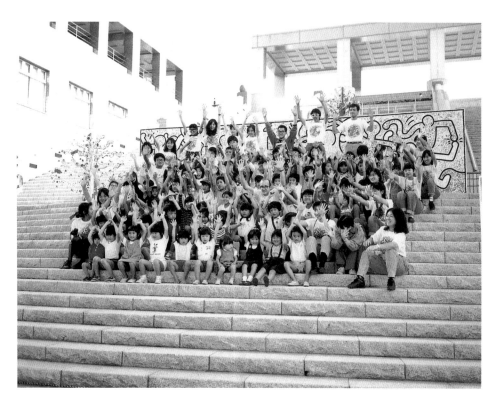

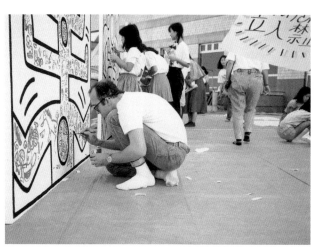

Keith Haring at work for Tama City,
collaborating with children

"He was very eager and asked me to guide him around every morning, and he even wanted to bring his own materials for the mural project."
—Mr. Yoshiaki Hanazawa, of Picasso Gabo who attended to Keith for 3 days.

「1人で毎朝案内を求める様子は必至で、壁画制作には材料を持参するとまで言って、熱心でした」。
—3日間アテンドをしたピカソ画房の花澤良章さん談。

HIROSHIMA
Offset-lithograph on poster paper
72.8x102.7cm, 1988

Keith Haring with Mrs.
Chizuko Sado at Picasso Gabo,
Hiroshima City, 1988

Hiroshima Peace Project

In August 1988, there was a project proposed to create a mosaic drawing on the walls of the Hiroshima City Honkawa Elementary School, located on the opposite shore of Ota River (Honkawa), which flows alongside the Hiroshima Peace Memorial. Unfortunately the mural was unable to be realized, but the same year, Keith was commissioned to create the poster for the Hiroshima Peace Concert, entitled "Of course we prefer peace." He visited the Hiroshima Peace Memorial Museum, witnessed the tragedy and wrote in his diary, "This must never happen again." His "Altarpiece,"[1] completed two weeks before his death, is imbued with Keith's deep wishes for world peace; his friend Yoko Ono donated one of the edition to the Hiroshima Contemporary Art Museum in 1997.

1 Includes St. John the Divine in New York (USA), Grace Cathedra in San Francisco (USA), Ludwig Museum in Cologne (Germany), etc.

広島平和プロジェクト

1988年8月、原爆ドームの前を流れる太田川（本川）の対岸にある広島市立本川小学校の壁面にモザイク画を描く企画があった。残念ながら壁画制作は実現できなかったが、同年　広島平和コンサート「平和がいいにきまっている」ポスターのメインイメージを描いた。広島平和記念資料館に訪れ、被爆の惨禍を目の当たりにし、二度とあってはいけないと日記に残す。キースの世界平和に対する想いは、亡くなる2週間前に完成した遺作「オルターピース」（祭壇飾）[1]に結集された。エディション9点のうち1点が1997年にオノ・ヨーコから広島現代美術館に寄贈される。

1　AIDSメモリアルの大聖堂として知られる、ニューヨークの聖ヨハネ大聖堂、サンフランシスコのグレース大聖堂をはじめ、ケルンのルドヴィグ美術館など世界各都市に点在。

73

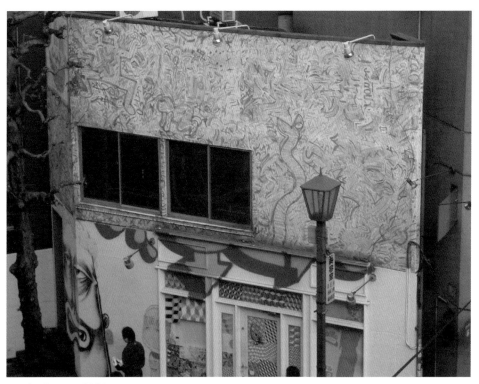

Mural at Present 2009

First Solo Exhibition in Tokyo
Keith's first trip to Japan, and in fact his first overseas expedition, took place in February 1983. His solo exhibition was held at the Gallery Watari in the Gaienmae area of Tokyo, for one month beginning in March. The highlights of the exhibit included his open studio in the two-story building across the street from the gallery, as well as the fact that he painted the walls there—everywhere and anywhere, inside and outside. Keith, with his assistant Little Angel (aka LA) and his friend Juan Dubose, scampered quickly across the scaffolding and spray-painted everything in the blink of an eye—a portion of this work still remains today. The event was broadcast on News Center 9 on NHK with the title, "Keith Haring—The Voice of New Painting"

東京での初個展
初来日は１９８３年2月。キースにとってこれが初めての海外遠征となった。3月から1ヶ月の間、東京外苑前のギャラリー・ワタリで個展を開催している。ハイライトはギャラリー前の２階建ての建物でのオープンスタジオと、外も内もところかまわず壁画を描いたことだ。現在でもその一部は残っているが、キースがアシスタントのリトル・エンゼル（通称：L.A）と友人のホアン・デュボォゼとともに、足場を駆けながら、カラースプレーであっという間に描ききった。その様子は「ニュー・ペインティングの旗手キース・ヘリング」としてNHKの『ニュースセンター９』で放映され、ブームを巻き起こす。

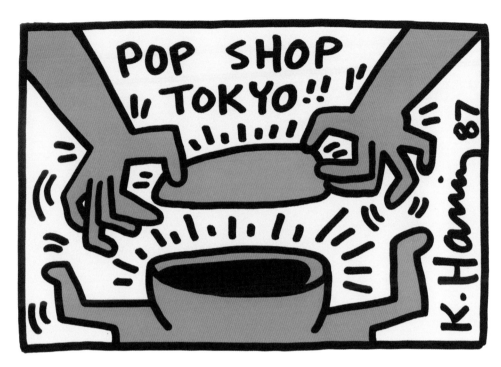

SURPRISE PARTY
BY
KEITH · HARING
1988·FEB/2(TUE) PM6:00～

1,500 YEN

Pop Shop Tokyo
In January 1988, a Pop Shop was opened on an empty lot along Aoyama Street. Because the rent was higher than expected, a container was used as the storefront. It was conceptually similar to his subway drawings: the shop came and went suddenly, temporarily, and in a guerrilla-like manner. Inside, the shop featured a variety of goods; parkas, telephone cards, stickers, and bags especially made for Tokyo, as well as Japanese-style items such as paper lanterns and beckoning cats. Customers were asked to remove their shoes, and wear slippers designed by Keith himself. Unfortunately, because of the mass counterfeit products, the store was closed in a year. The container used as the storefront is now in the possession of a French collector.

ポップショップ東京
１９８８年1月、青山通り沿いの空き地にポップショップを開く。予想外の賃貸料だったためにコンテナを利用。その形態は、サブウェイドローイングのように一時的に、そしてゲリラ的に出現し、いつの間にか消えて行くコンセプトに通じるものでもあった。店内には、東京用にデザインされたパーカーやテレフォンカード、シール、袋類などや、日本を意識した提灯や招き猫といった和風のお飾りも取り入れ、数々のグッズを販売。客は靴を脱ぎ、キースがデザインしたスリッパを履くスタイルをとった。しかし、偽物の氾濫などもあって、1年で閉店してしまう。店舗としてつかわれたコンテナは、現在フランスのコレクターのもとにある。

Selected Biography
略歴

1958
Born on May 4 in Reading, Pennsylvania and grows up in Kutztown.

1977–8
Graduates from high school and moves to Pittsburgh. Inspired by a Retrospective of Pierre Alechinsky at the Carnegie Museum of Art. Has his first solo exhibition at the Pittsburgh Arts and Crafts Center.

1978–9
Moves to New York and enrolls in the School of Visual Arts (SVA). During this period he becomes friends with Kenny Scharf, John Sex and Jean-Michel Basquiat. Keith participates in the Nova Convention and is inspired by William Burroughs and Brion Gysin.

1980
Curates an exhibition at Club 57 and at PS 122. He works at the Tony Shafrazi Gallery as assistant. Shares a studio in Times Square with Kenny Scharf.

1981
Starts his series of subway drawings on the blank advertising panels in the subway. Moves to his studio on Broome Street.

1982
Exhibits his works at the Paradise Garage. Organizes a joint exhibition with LA II at the Tony Shafrazi Gallery. Selected in the Documenta 7 in Kassel, Germany.

1983
Has a solo exhibition at the Fun Gallery in New York and exhibits drawings on a desk originally created by Kermit Oswald. First visit to Japan with a solo exhibition at Galerie Watari. Has a body painting session with dancer/choreographer, Bill T. Jones in London. Selected in the Whitney Biennial, New York and the Sao Paolo Biennial.

1984
Selected in the Venice Biennial. Paints murals around the world including Sydney, Melbourne, Rio de Janeiro and Minneapolis. Creates the set for the ballet "Secret Pastures" choreographed by Bill T. Jones and Arnie Zane. Organizes the first Party of Life to celebrate his birthday. With 3000 invitees and songs by Madonna (At the Paradise Garage).

1985
Selected in the Paris Biennial. Has a exhibition at the Leo Castelli Gallery with large-scale painted steel pieces. Designs watches for Swatch and a logo for

78

1958
5月4日、アメリカ、ペンシルバニア州のレディングに生まれ、カッツタウンで育つ。

1977–8
高校を卒業後、ピッツバーグに移る。カーネギー美術館で開催された、ピエール・アレシンスキーの大回顧展に感銘を受ける。ピッツバーグのアーツ・アンド・クラフツ・センターで初個展開催。

1978–9
ニューヨークに移り、スクール・オヴ・ヴィジュアル・アーツ に入学。この頃、ケニー・シャーフ、ジョン・セックスそしてジャン＝ミッシェル・バスキアらと知り合う。ノヴァ・コンベンションに参加し、ウィリアム・バロウズとブライオン・ガイシンに強い影響を受ける。

1980
クラブ57にて展覧会のキュレーション、P.S.122でも展示を企画する中、トニー・シャフラジ画廊で助手として働く。

ケニー・シャーフとタイムズ・スクエアにあるスタジオをシェアする。

1981
地下鉄の広告板を使ってサブウェイ・ドローイングを開始する。ダウンタウンのブルーム ストリートにあるスタジオに移る。

1982
パラダイス・ガラージで1ヶ月ドローイングを展示。LAIIとトニー・シャフラジ画廊で展覧会。ドクメンタ'82（ドイツ、カッセル）に参加。

1983
ファン・ギャラリーの個展でカーミット・オズワルドが制作した机に描いた作品を出展。日本に初来日。ギャルリー・ワタリで個展。ナポリで初のボディー・ペインティングを試み、ロンドンではダンサー兼振付師のビル・T・ジョーンズに施す。ホイットニー・ビエンナーレ（ニューヨーク）、サンパウロ・ビエンナーレに参加。

1984
ヴェネツィア・ビエンナーレ参加。シドニー、メルボルン、リオ・デジャネイロ、ミネアポリスなど世界各都市で壁画を制作。ビル・T・ジョーンズとアーニー・ゼインが振付をしたバレエ『シークレット・パスチャーズ』の舞台セットを手がける。パラダイス・ガラージで、誕生日を祝うパーティー・オブ・ライフの第1回目を開催する。マドンナも参加し、約3千人が集う一大イベントとなる。

1985
パリ・ビエンナーレに参加。レオ・キャステリ・ギャラリーで金属にペイントした大型の彫刻展を開催。スウォッチの時計デザイン、ドイツ製薬会社の商品ラベルのデザインを手がける。反アパルトヘイトのポスターを2万枚制作。ユニセフのアフリカ緊急援助基金のための展覧会「レインダンス」開催。リキテンスタイン、オノ・ヨーコ、バスキア、ウォーホルらとポスターを制作。ブルックリン音楽アカデミーで

a German pharmaceutical company. Prints 20,000 anti-apartheid (Free South Africa posters). Participates in the "Rain Dance", an event organized by the UNICEF US Committee for African Emergency Relief Fund and creates posters with Lichtenstein, Yoko Ono, Basquiat and Warhol. Creates sets for the Brooklyn Academy of Music's "Sweet Saturday Night." Paints a 10-metre wide set for the Palladium, a New York disco designed by Isozaki Arata.

1986
Stops subway drawings. Exhibition at the Stedelijk Museum in Amsterdam. Opens the Pop Shop in New York. Paints "Crack is Wack" mural in New York. Creates a huge banner with more than 1000 children for the Centennial of the Statue of Liberty. Collaborates with

Brion Gysin in "Fault Lines". Draws a 100 meters mural on the Berlin Wall. Start the "Andy Mouse" series.

1987
Exhibits at the 10th year Anniversary Exhibition of the Pompidou Center in Paris. Draws on the staircase of the Necker Children's Hospital in Paris, France. Participates in the traveling amusement park "Luna Luna" in Munich with other artists such as Lichtenstein, Hockney, Basquiat, Joseph Beuys, Dali etc. Solo Exhibition in Antwerp, Belgium. Creates art works at Parthenon Tama in Tokyo with 500 children.

1988
Opens the Tokyo Pop Shop. Exhibits at the "Art Against AIDS" exhibition in New York. Has children workshops in Chicago, Atlanta and

Washington D.C. Creates a work "Easter at the White House" and donates it to the Children's Hospital of the National Medical Center in Washington D.C. Collaborates with William S. Burroughs for "Apocalypse." Is diagnosed with AIDS.

1989
Is active in various AIDS-prevention campaign. Carries out mural projects in Barcelona, Monaco, Iowa City, Chicago, New York, Pisa and the San Antonio Church. Establishes the Estate of Keith Haring.

1990
Dies on February 16 in Greenwich Village due to AIDS-related complications.

公演された『スウィート・サタデー・ナイト』の舞台セットを手がける。
ニューヨークのディスコ「パラディウム」（磯崎新設計）で10メートルの大作制作。

1986
サブウェイ・ドローイングを中止。
アムステルダム、ステデリック美術館で個展。
ニューヨークにポップショップを開店。自らデザインしたオリジナルグッズを販売する。ニューヨークに壁画「クラック・イズ・ワック」を制作。
自由の女神100周年記念のため、1千人以上の子供たちと巨大な自由の女神像を垂れ幕に描く。
ベルリンの壁に約100メートルの壁画を描く。
アンディー・ウォーホルに捧げた作品「アンディ・マウス」シリーズ制作。

1987
パリ、ポンピドウー・センターの開設10周年記念展に出品。

フランスの小児科病院オピタル・ネッカーの階段にドローイングを描く。
ミュンヘンの、アーティストによる巡回遊園地「ルナ・ルナ」に、リキテンスタイン、デイヴィット・ホックニー、バスキア、ヨーゼフ・ボイス、ダリらと共に参加。
ベルギー、アントワープで個展。
東京、多摩市のパルテノン多摩で約500人の子供たちと絵を描く。

1988
東京にポップショップを開店。ニューヨークの「アート・アゲインスト・エイズ」展に出品。
シカゴ、アトランタ、ワシントンDCで子供たちとワークショップを開催。ホワイトハウスにて「ホワイトハウスの復活祭」を制作し、ワシントンの小児病院に寄贈。
ウィリアム・バロウズと版画『アポカリプス』を制作。
エイズと診断される。

1989
エイズ予防のキャンペーンに従事。

バルセロナ、モナコ、アイオア・シティ、シカゴ、ニューヨーク、ピサ、サンアントニオ教会で壁画を制作。ウィリアム・バロウズと『谷間』を制作。
キース・ヘリング財団設立。

1990
2月16日、ニューヨークのグリニッジ・ヴィレッジのアパートでエイズにより死去。

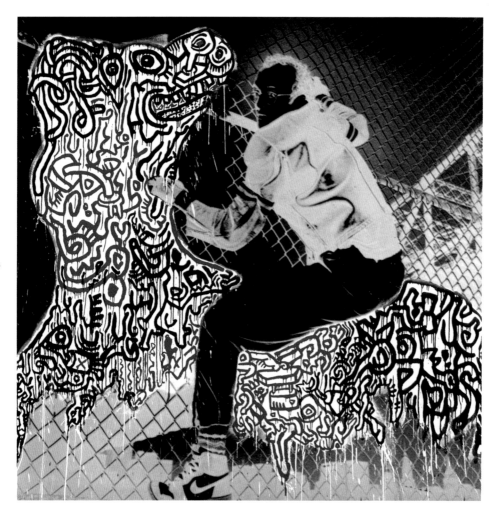

UNTITLED (SELF-PORTRAIT)
Photograph by Gianfranco Gorgoni
Mixed media
245x245cm, 1988

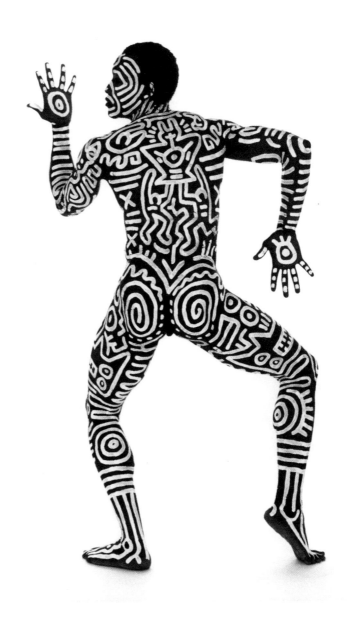

Bill T. Jones body
painting with Keith
Haring, 1984

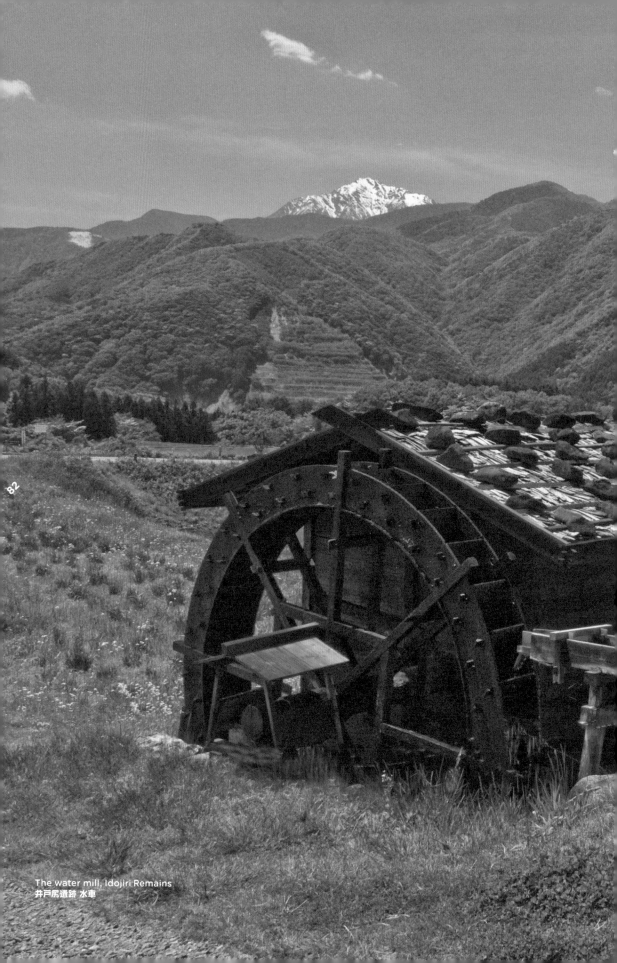

The water mill, Idojiri Remains
井戸尻遺跡 水車

Horseback riding
in Kobuchizawa
乗馬、小淵沢

Mt.Yatsugatake
八ヶ岳

Afterword / 後記

Nakamura Keith Haring Collection was built in 2007 on the skirts of Yatsugatake Mountains, a volcanic land where in ancient times the Jōmon culture flourished. Yatsugatake has the longest daylight hours in Japan, and is comparable to the environment of the womb of a mother.

The Collection belongs to Kazuo Nakamura, and is an amalgamation of the chaotic, yet intense energy that took place in the 1980s NYC art scene. The museum operates under the theme of "a museum that transcends museums," and begins with a long dark slope entitled "An Approach to Darkness" and leads to "The Gallery of Darkness" where Subway Drawings are dramatically exhibited. From there we are lead to the "Giant Frame", and then to an area that consists of love, dreams and hope, the three pillars of the Collection, entitled "The Gallery of Dreams," where the masterpiece painting "People" is displayed. In this land, Haring's Big City art, is reborn by absorbing history and the power of the great nature.

中村キース・ヘリング美術館は、2007年に八ヶ岳の裾の尾の大自然の中に建設される。古代縄文文化が隆盛を極めた、活火山のエネルギー漲る土地である。標高1千メートル、日照時間が日本で一番長いというその気候は、生命を育む母体の環境とも比較される。

コレクションは、中村和男氏が1987年から蒐集を始めたキース・ヘリング作品約130点からなり、混沌とした、しかし猛烈なエネルギーを放出した80年代のニューヨークで生まれたアートが凝縮している。美術館は中村和男氏の「美術館を越えた美術館」をテーマのもと、洞窟のような暗いスロープ「闇へのアプローチ」に始まり、ニューヨークの地下鉄で始まったサブウェイドローイングの作品を劇的に展示した「闇の展示室」、企画展の舞台となる「ジャイアントフレーム」、そして広大な空間に大きな彫刻作品や絵画の大作「ピープル」を展示する「希望の展示室」へと続いていく。中村コレクションの根源となっている、愛と夢、そして希望のメッセージを伝える空間だ。大都市の喧噪の中から生まれたキース・ヘリングのアートは、今この地の持つ自然の力と歴史を吸収し甦る。

Photography Credits
All Keith Haring artworks courtesy © Keith Haring Foundation
© Jacques De Melo (Cover, Pp. 8–9, 10–11, 16–17, 18, 24, 29, 33, 37, 42–43, 82–83, 84–85 and 88–89)
© Takumi Ota (Pp. 19, 30, 50–51)
© Atsushi Kitagawara Architects (Pp. 66–67)
© Hokuto City Goverment Office (Pp. 86–87)
Photographs by Tseng Kwong Chi © Muna Tseng Dance Projects, Inc (Pp. 47 and 81)
Courtesy Idojiri Archaeological Museum (Pp. 34 and 57)
Courtesy Nagasaka Local Resource Center

総監修 梁瀬薫
翻訳 中保佐和子 ゲルガナ・イヴァノヴァ ダン・ウィバー
AD+D Hinterland
編集 三上豊（和光大学）櫻林恵美理（中村キース・ヘリング美術館元主任学芸員）
印刷・製本 Cohber
発行日 2024年4月15日　新装版第1刷発行
発行者 中村和男
中村キース・ヘリング美術館
408-0044 山梨県北杜市小淵沢町10249-7
0551-36-8712
www.nakamura-haring.com
ISBN 978-4-9904168-6-7